Change in Art Education

THE STUDENTS LIBRARY OF EDUCATION

Change in Art Education

Dick Field

*Senior Lecturer in Education with special reference to
the teaching of Art,
Institute of Education, University of London*

... the world is open before us,
everything is still to be done and
not to be done over again.

PICASSO

LONDON
ROUTLEDGE & KEGAN PAUL
NEW YORK: HUMANITIES PRESS

First published 1970
by Routledge & Kegan Paul Ltd
Broadway House, 68-74 Carter Lane
London, E.C.4
Printed in Great Britain by
Northumberland Press Limited
Gateshead
© D. Field 1970

SBN 7100 6675 9 (C)
SBN 7100 6676 7 (P)

THE STUDENTS LIBRARY OF EDUCATION has been designed to meet the needs of students of Education at Colleges of Education and at University Institutes and Departments. It will also be valuable for practising teachers and educationists. The series takes full account of the latest developments in teacher-training and of new methods and approaches in education. Separate volumes will provide authoritative and up-to-date accounts of the topics within the major fields of sociology, philosophy and history of education, educational psychology, and method. Care has been taken that specialist topics are treated lucidly and usefully for the non-specialist reader. Altogether, the Students' Library of Education will provide a comprehensive introduction and guide to anyone concerned with the study of education and with educational theory and practice.

In educational practice the revolutionary ideas of yesterday have become the stereotyped formalities of today. Mr. Field, with a wide experience of art education at all levels of the curriculum from primary school to university, is convinced that a searching review of present practices and of the theoretical assumptions underlying them is as necessary in this as in all the other curricular areas now being considered. It is indeed somewhat ironical that art education, which played something of a pioneering role in those earlier changes as an area whether the needs of young children to express themselves freely was most fully recognized, has not so far figured very prominently in current curricular inquiry and research. It is true, as Mr. Field points out, that the emphasis has changed and he illustrates this by lucid accounts of the bearings on art education of Piaget's work and recent research into creativity.

The many college of education students with art as a main subsidiary subject will undoubtedly be led to question some of their most cherished assumptions if they read this book: the nature of the 'art lesson' for example; the teacher's role in the provision of 'ideas' for expression; the function of materials and media; the compartmenting of art in its relation to other activities in a long-term educative process; the concentration of art in the art room; the assumption that the secondary school and the college of art are doing the same thing. One of Mr. Field's main themes is that the function of

art in general education should be concerned with 'developing and understanding art, rather than concentrating on personal achievement in art'. From this base he outlines a campaign for the transformation of art education in the secondary and tertiary stages.

<div align="right">J. W. Tibble</div>

Contents

CONTENTS

Preface

This book is not intended to be comprehensive, nor to be read in isolation; necessarily the ideas and theories of others are referred to only briefly, and reading among the books listed at the end is essential if the reader wishes to consider seriously the picture of art education presented here.

Nor do I pretend to have put forward anything new: only I have drawn on my own experience and on some of the mass of material now available to art educators to attempt to put together in a small space a statement about the unity of art education. Accordingly I owe a great deal to many children, students, teachers and writers: I hope that I may be forgiven if I thank them all together. The books which I have used appear (with some additional recommendations) in the bibliography.

I must, however, add how deeply I am indebted to my former colleagues in Hertford, the West Riding of Yorkshire, Birmingham and London, with whom I have spent so many hours discussing art in education; and in particular to Basil Rocke, formerly Senior Art Adviser to the West Riding. Basil Rocke worked and thought intuitively, and if he were alive today would no doubt find much to discuss in this book. Nevertheless, in a very real sense many of the ideas and attitudes expressed here derive from the talk and practice we enjoyed together between 1949 and 1953. I must also thank those of my present colleagues who have read the manuscript and have made valuable suggestions; and finally to my wife, who has not merely been patient and encouraging, but who has talked over with me most of the substance of this book. I alone, however, accept responsibility for what I have actually written.

<div align="right">

D. F.

ix

</div>

I

The contemporary scene

INTRODUCTORY

This book is concerned with the contemporary scene in art education in this country. We shall look at something of what goes on in the classrooms, artrooms, studios and workshops of our schools and colleges; at what are thought to be the aims of the activities that we find there; how these aims relate to or grow out of contemporary educational thought and disciplines, and how far they spring from other older ideas and attitudes; the forms that these activities and aims take in practice. We shall observe the changes that have overtaken art education, and look at some of the many influences that have acted upon the ideas and practices of art teachers. We shall consider ways in which the current situation might develop.

One of the more remarkable phenomena of the last thirty years in our schools has surely been the spread of practical art. In very few schools is there no provision for art, and in our best new schools there are magnificent studios and workshops. equipped and designed for one thing only: that children may practise art. In fact, virtually every child who goes to school has the opportunity of taking art at least weekly for the first eight years of his schooldays. Many children continue for a further three to five years, while increasing numbers of young people are specializing in art at colleges of art or in colleges of education. Although the total picture is an obscure one, certainly here there seems to be an indication that our

society is concerned that art shall become a better understood and more truly felt part of our lives.

Yet at the same time the procedures of the art teachers, whose task it is to put this concern into practice, are characterized by confusion and lack of direction. Despite the profusion of books on art education, despite the activities of inspectors and advisers, despite a certain renewed interest in the art of teaching art, the future seems unclear. Art education in this country suffers from a chronic weakness in communication; partly because of the mystique with which the art teacher has so often surrounded his work, partly because of genuine differences of opinion or belief stemming from old disputes in the world of art, partly because when the art teacher does talk he so often becomes too preoccupied with means to discuss ends (in which he is by no means alone among educators). The national societies (e.g. the National Society for Art Education, and the Society for Education through Art) represent different groups and different points of view, and neither is large enough to act as a real focus for the development and dissemination of ideas. There is no national clearinghouse for information. Above all, practically no research is being done; the teacher proceeds in a vacuum. Undoubtedly at this moment, all over the country, excellent work is being carried on by numbers of art teachers isolated in their schools; the value of what they are doing not always recognized on the spot nor even by themselves, and certainly with little chance of attracting notice outside the school. No one would suggest that a teacher's first duty is not to his pupils, but art education as a whole is certainly the poorer for lack of any really adequate system of communication. Finally, of course, the problems of art education are in constant flux, and the identification of new problems and reaction to them at present falls naturally on isolated individuals. It is not always the teacher in the field who is the first to become aware of new ideas; there is a considerable mass of written material available and it is steadily increasing. Here is evidently a particular area where new developments are urgently necessary.

DEFINITIONS

Something must be said in explanation of the way in which the words Art and Art Education are used here. Most people still think of the school-subject as Art and Crafts. Most colleges of art and colleges of education are shedding this name, feeling that although it once reflected accurately the nature of what was done, it no longer does so. In this sub-division, Art originally meant the fine arts – painting and sculpture; latterly in schools it came to mean drawing and painting, and still means this to a great many people; Crafts meant the useful crafts of pottery, weaving, basketwork, etc. It is amusing to read the detailed story of craftwork in schools (Sutton, 1967). But one major effect of the revolution in the use of materials in the nineteen-forties and -fifties was that all materials began alike to be used for expressive purposes; the distinction between the un-useful arts and the useful crafts became invalid. Hence the current search for a new name. Art alone is now often used, the argument for it being that the kind of activity which was formerly signified by the word Art has extended itself by taking over many of the materials and techniques of the crafts. I have used Art generally in this sense, but there is no denying its inadequacy: for most people Art still means painting. Design has come into fashion in the schools of art, presumably because of the Diploma in Art and Design; but does this mean Design as a synonym for Art, or does it mean design for industry and commerce? The latter seems more likely, in which case its use is not very appropriate at present to describe what goes on in schools of general education and in colleges of education. Art is used here, therefore, in the general sense – not simply meaning drawing and painting; while crafts is used in the old sense – to mean using accepted or traditional techniques to make objects for use.

Art Education is a kind of portmanteau phrase, sometimes meaning art in schools of general education, sometimes art in schools of art, and complicated by all the overtones of art in education or art as an educational means. It is not precise in use, though perhaps most people when they use it have

3

the idea of education through art in the backs of their minds. I have used the phrase to mean education in art, at whatever level and in whatever institution; though I have tried to make it clear when what is being said applies only to particular groups. By education *in* art I mean primarily an understanding of art as a mode of organizing experience.

CHILDREN'S ART

Children's art is the art which children make. Put a pencil or a crayon into the hand of a child a year or more old and let him have a surface on which to draw. The free spontaneous movements of his hand and arm will produce scribbles upon the paper. To the marks thus made he will respond; gradually his scribbles will become differentiated (see Kellogg, *What Children Scribble & Why* or her new book *Analyzing Children's Art*) until – a year or more later, and most likely of his own volition – he will draw a head. Upon this simple, undirected beginning all that follows in art is built: the complex evolution that takes the individual child through the 'child-art' period of seeing things as wholes, into the later years when he laboriously tries to assemble a whole by adding together parts, until finally he leaves school and perhaps ceases to draw at all.

The sequence holds good for most children. Each progresses through well-defined steps from scribbles to abstract shapes or figures; and through figures by again well-understood steps from heads with limbs to heads with triangular bodies and so through a series of formulae (Lowenfeld calls them schemata (Lowenfeld, 1939) until, usually some time after the child has reached the age of nine (though such figures must be treated with the greatest caution) the generalized nature of the schema is no longer appropriate to his way of learning about his world. He is in process of developing analytical ways of thinking, and his ways of organizing his material – one of which is through art – must develop also. From this time on, development becomes to an increasing degree individual, and no generalized statements are possible – some children

4

continue to find satisfaction in art activity; some give up. Perhaps because of the pressures our secondary schools develop, few children are able to find validity in their art.

It was the work of younger children which first attracted the attention of educators, and more than a hundred years ago began to convince them that there were better ways of teaching art to children than simply to assume that they should learn skills. As far back as 1854 Herbert Spencer (Spencer, 1861) was writing in condemnation of drawing from copies, 'and still more so, of that formal discipline in making straight and curved and compound lines, with which it is the fashion of some teachers to begin'; while Ruskin (Ruskin, 1857) wrote, 'I do not think it advisable to engage a child in any but the most voluntary practice of art . . . it should be allowed to scrawl at its own free will'. Since that time a host of distinguished educators have followed Ruskin and Spencer in recognizing that the spontaneous drawings of children have values, psychological and aesthetic. The various stages of development of young children and their drawings have been thoroughly charted, and the basic process of learning in art – the organization of experience in a schema; the repetition of the schema crystallizing experience, until new experience modifies the schema; further repetition of the schema in its new form, and so on – has been confirmed. The formal and intuitive values in children's art have been recognized – the unity of conception and presentation, the sureness of line, the certainty of placing, the vitality of colour, and above all the innocence and sincerity that are transparently plain. If there were those in early days who saw that above all, young children need encouragement and opportunity to draw, it has been an article of faith since that time with progressive art educators that the truest and most successful way of helping children to the experience of making art is to start with the kind of image-making which children do spontaneously.

The impetus given to art education by the pioneers (Ebenezer Cooke, T. R. Ablett, and later Marion Richardson, in this country; and Professor Cizek in Vienna) has not yet been entirely lost. The story of the development of art education

in Britain reveals the constant enthusiasm, dedication and inventiveness of numbers of art teachers, and underlines the life-giving relationship between the vitality and innovation of the world of the professional artist and the world of the class-room, the artroom, the workshop. It also makes more clear the relation between theory and practice; the many efforts to establish a true growth from the spontaneity of early child-hood; the frequent compromises necessary at some times to attempt to secure continuity of creative work throughout the secondary school, at other times to ensure that development went towards adult concepts and standards; for throughout the whole period art teachers have thought of art in school as an activity – children practising art. It is at this concept that we must now look.

ART AS A PRACTICAL SUBJECT

When drawing first appeared in English schools in the eighteen-thirties and -forties, the intention of the exercises set for children was at bottom to develop skill. Courses of training were strictly practical; at first involving the freehand drawing of straight lines of different lengths and the judging of their direction and length; later including the making of freehand copies, the notion being that the child in copying outlines of beautiful shapes – acanthus-leaves, for example – would im-bibe the principles of beauty. The basis of the whole idea was that the teacher had in mind a direction and a goal, which children should achieve by practice.

Earlier even than this Froebel had had ideas about practical work in art which much later had a profound influence on the teaching of young children in this country. He devised a series of exercises or Occupations, not simply with the intention that these should be used solely for the practice of skills, but that they should also be used educationally. However, long before his writings were translated into English, the schools were al-ready committed to practical art. From this point onwards, although the arguments change, there is no serious challenge to this situation. Indeed, once the vitality of children's art was

6

recognized, there could be no turning back, though of course many new theoretical justifications for practical work were propounded. At some of these we must now look.

Perhaps the earliest of these arguments is simply that value attaches to children's art. If children can make things of value, let them do so. Cizek responded with delight to the work of young children; and since his time many art teachers have felt themselves content to create a situation in which children can produce work in which the teacher sees quality. An extension of the argument might be 'not only do children make beautiful things. The arts are man's most disinterested and valuable activities: it must therefore be good for children to participate.'

A further line of argument emphasizes the nature and quality of the activity; it points to the artist, who must first seek and recognize his subject, must decide on the shape and material he will use in making his response, must make further decisions on form as the thing grows and changes, must persist sensitively and with determination to carry the work through to completion. Even this brief statement emphasizes the complexity of the art-making process, and makes it clear that skills and insights of a high order must be called into play in engaging this process. Moral values are also involved. The whole activity employs the whole person – mentally, physically, emotionally; and in the integration of all its elements becomes an educational process of unique value.

This argument, which was current in the nineteen-forties, is obviously pre basic-course; it does, however, run as a precursor of arguments based on the idea of creativity. Any analysis of the activity of the artist and of the abilities he must deploy brings us to the threshold of the Lowenfeld/Guilford investigations of the fifties (at which we shall look in the next chapter). The whole foundation of organization upon which art teachers have worked – freedom for children to develop their own ideas, opportunities for choices, encouragement of originality and unconventional thinking (however much modified and weakened in action) – is one conducive to the exercise of creative abilities. Indeed, there have been times when the

7

art teacher might feel, with some justice, that his subject almost alone in the curriculum offered opportunities for children to be creative. He surely cannot any longer feel so – and may well feel that he is being left behind, and that recent developments in other subjects have been more spectacular and more systematic.

Finally, in considering reasons why art in schools has always been a practical subject, we must again refer to art and learning. For when young children draw, aspects of their view of their world are being confirmed or modified in accordance with changing experience. In this recurrent process it is not merely that the child's drawing reflects his concepts: it plays a part in their formation.

It can be seen that among these arguments in favour of art as a practical activity some are sufficiently potent to apply to the present and future as well as to the past. Indeed, it is now normally accepted both by educationists and laymen that, as a standard part of the educational provision, all children ought to have the opportunity of practical work in art regularly and frequently throughout their school career. In fact of course not all children do, but this is a matter of exigency, not principle. It still remains the goal of art teachers that all children shall practise art once a week. The reasonableness of this goal is a matter that we shall discuss further.

VALUES IN ART EDUCATION

Evidently the arguments we have just been discussing, in favour of art as a practical subject in schools of general education, are also arguments in favour of art as a subject. Art as a worthwhile activity, the perception of beauty, the teaching of skills, art as a medium in the process of learning, the value of creative activity, plus the general educational idea of art as a process of initiation into adult ways in art: these are all arguments used at different times to support the inclusion of art in the curriculum. All these arguments have had their day, and – with one exception – would be generally acceptable today. The exception is the teaching of skills. One of the marks

8

of the unhappy cleavage between art and handicraft teachers in the schools lies in their respective attitudes to skill: for many years now the art teacher has tended to regard the acquisition of skill as a by-product rather than a central feature of creative activity. This has been a matter of relative priorities: the art teacher's emphasis has been on spontaneity and vitality; unless skill is second nature it can be a hindrance to these qualities; therefore the art teacher has only encouraged such skills as are indispensable. This is not necessarily to say that there is no value in acquiring skill; it can be argued that one of the weaknesses of art education at the present day lies precisely here, that incompetence has become a virtue.

Besides these arguments, it is sometimes suggested that objectives be synthesized: as in the idea of the practice of art as developing personality, or art as primarily the study of communication. In so far as such proposals embody the particular enthusiasms of individual teachers there must be a place for them; but it is necessary to note that they conceal widely divergent elements beneath their apparent simplicity.

This book takes up Dewey's idea that out of the amorphous studies of the young child different forms of knowledge will differentiate, and uses this as a basis for the proposition that the general function of art education is to lead children towards an understanding of art as a means of organizing experience. Such a proposal has the advantage of not being tied to particular procedures and methods, although we shall see later that it does have certain implications relative to these.

Because art teachers in schools have often enough felt the need to justify their subject in others' terms, they have sought for other values with which to support the inclusion of art in the curriculum. Two arguments in particular have been urged – the therapeutic and the recreational: the one proposing that art helps children to be saner, more balanced – that they paint out their fears and troubles; the other suggesting that after their serious work in other subjects children need relaxation – which art provides painlessly within the framework of the curriculum. It is easy to see how these arguments have rebounded; they imply a trivialization of the genuine qualities

9

in children's art, and the latter in particular attacks the dignity of art as a mode of thought. They are not without truth, but the aims they state cannot be central to art education.

Even more insidious is the notion of acceptable art. If children's art has positive values which justify the making of art in school, then what children do must be scrutinized by the teacher, and accepted by him. For various reasons, however, by no means all that children do is likely to be readily acceptable: it may be crude, it may appear to affront human dignity, it may make statements which are taboo in school or society. Hence the teacher is under pressure to ensure that only acceptable images are made. It is easy to see that false values may interpose here, and because they may remain concealed even from the teacher, may assume a dangerously strong position. It is therefore essential that art teachers should be as clear-sighted as possible about their own predilections.

Many teachers have been aware that their own responses might have more influence than they thought desirable. There has been a long period of minimum interference on the part of the teacher, springing originally from a very simple and straightforward idea. Art is a personal matter, goes the argument; its decisions and choices are the concern of the artist alone; so should it be with children. The teacher might provide materials and equipment, suggest subjects, set the stage; but once the child had started work the teacher must stand aside. Free expression was the aim. Clearly the teacher retained a considerable degree of control; even so the procedure – perfectly reasonable with young children – was understandably less successful with older children inadequately prepared.

We must underline the fact which is almost stated in the last paragraph: a great many teachers have always strongly held that what children do in art lessons must be art, and not merely a means to art. That is, when they do practical work they are not doing exercises today in the hope that these will improve their art tomorrow, or next week, or next year. This belief arises originally, perhaps, in the feeling that children's art should be spontaneous (it has sometimes almost seemed

that teachers have wanted children not to know too much, not to be too skilled, lest the quality of the work should suffer). It may also represent a lengthy reaction against old-style art education, typified in the old art-school drawing examination, with its emphasis on life drawing, antique drawing, perspective drawing – all designed as means to some future end.

At all events, the result has been that children throughout general education were, as the normal thing, asked in the art lesson to tackle a total problem – such as making a picture, with its incredibly complex organization both formal and associative, its immense compromises, its endless uncertainties. Of course young children are always doing this with gusto, unaware, without fear; but children do not remain in this unsophisticated state for ever, and as they grow older the problems loom ·larger. By their belief, teachers were prevented from isolating a problem and enlarging it; they were, of course, influenced by their ideas of what art is: so long as a picture typified art, that was that. Not until teachers realized that the artist himself was isolating and identifying his problems was it possible for the art teacher to do the·same.

Finally, we must note a perplexing feature of the art teacher's situation. He is concerned to promote creative activity with an end-result. His job is, he believes, to engage children in the practice of art because it 'is good for them'. What should be his attitude to the thing made? Is it merely the evidence of experience? His whole training makes him dubious of this. He finds himself responding to the qualities of the thing made – indeed, much of his teaching is likely to be directed towards improving it (teachers have been known to take work away from the child before it was finished, so that it should not be spoilt) – and finds great difficulty in separating this response from his attempt to assess the value of the experience of working to the child. The truth is of course that the two are not separable. You can only make art by making some thing. The very essence of the experience is the working on material with idea; the embodying of idea in material form. The superficial view, however, that if the teacher thinks a piece of work 'good' then the experience

of making it was also 'good', is an over-simplification of a far more complex relationship. The art teacher who merely pins up on the wall the work which he considers good, is certainly doing an injustice to some children in the class; but worse than that, he has not really understood one of the fundamentals of art teaching.

DAY TO DAY PROCEDURES

Let us now take a quick look at art education in schools of general education in day to day terms. We have observed that almost all children practise art weekly for a period varying from three-quarters of an hour to a whole morning or afternoon. They will meet – generally as a whole class of about forty children in a junior school; sometimes as a smaller group in a secondary school – the former in a classroom, the latter in an art room or workshop. They may begin a new piece of work, or continue with a piece already begun. If it is a new piece, there will be an introductory talk or discussion, not often very lengthy; time not spent in practical work is likely to be thought of as wasted. Sometimes the class will be taught as a single group, sometimes it will be broken up into smaller groups; very rarely everyone will be differently engaged. Once materials have been given out – which may be before or after the introduction – the children will begin and the teacher will talk to individuals about their work; he will normally continue this until it is time to end the lesson.

All that has been said thus far points to the art teacher's concern with the individual. In this the art teacher is not alone; he is part of a larger movement. Yet perhaps his choice of a career as an art teacher, the kind of training he has had, his own characteristics, all indicate a predisposition to such a concern. It will show in his eagerness to move on from working with the group to making contact with individuals, in the freedom he allows in work, movement about the room, conversation; it will show in his attitude to materials.

In the artrooms of the thirties only certain standard or traditional materials were in use. Pencil or crayon, powder-

colour and water-colour, occasionally oils; paper; potato and lino with which to print; papier mâché and sometimes clay for modelling; cardboard for models. Children sometimes wove with wool collected by themselves in the countryside; dyes were handmade from plants according to traditional recipes; but the artists' suppliers were already able to provide the art teacher with the correct materials for the 'New Art' – hog-hair brushes, powder-colour, newsprint, sugar-paper. Some improvisation was beginning – so little money was available for art in schools that teachers bought drysalters' colours and mixed them with gum arabic or distemper or oil, and collected the ends of rolls of newsprint from the local printer.

During the war-years, shortages of almost all normal materials drove teachers to experiment much further with substitute materials, and as the years passed and such substitutes became normal teachers and children alike grew familiar with their use and with the look of work done with them. Even before the war such a medium as potato-printing had been praised because of its accidental effects; the problems of control with substitute media compelled all who used them to face the strangenesses of surface and line which looked back at them from the paper. At the same time the professional artist was becoming absorbed in the accidental: Henry Moore with his use of wax in the *Shelter Drawings* is an example.

From this wartime experience two strands developed which were to preoccupy art teachers for the next decade or more: the first was the interest in surface texture which, related to the use of the accidental and looking for its roots as far back as the first cubist works, led to a great deal of experiment to find new ways of making marks on surfaces. Children drew and printed with twigs, scratched on wood with nails, made prints from leaves, cork, and all sorts of odds and ends. The second development was that children began to take the materials they had been using as tools to use as the direct raw material of art. Bits of fabric, felt, wood, metal of all kinds, buttons, foils, sequins, clock-wheels, plants, leaves, bark, wire, tins, bottle-tops, offcuts of technical processes, scraps of plastic; all these and many others – mostly the debris of our

materialistic culture – were assembled to make both two- and three-dimensional objects, sometimes devised by the teacher, but often the result of the imaginative play of the children themselves.

This was a revolution indeed – brought about in the schools and by the teachers and the children – and it was a revolution in more than one sense. Not only was the range of possible materials greatly widened, but their use introduced a whole body of new ideas about what art made by children in schools might be. A glance at some of the current examination sylla-buses will give a fair idea of the concepts of the thirties; a visit to almost any artroom will reveal evidence of the materials revolution.

Art teachers found themselves compelled to face the im-plications of these new developments. It was clear, for example, that a great new responsibility was placed on both teachers and children; the old-style role of the knowledgeable or skilful teacher was not so easy to maintain; both teacher and child started from nearer to the same base; both had to invent or discover, to respond to the material, to find ways of using it, to accept the thing made. It was seen that the new situation encouraged a clarity of vision with respect to the material, a sincerity of response, which had always been thought desirable and had been sought, but was not always so easy to achieve with traditional materials used in the con-ventional way. Clearly, too, new concepts of skill must be developed; no longer was it enough to acquire a traditional skill. The new skills had to be learned while actually doing the job.

In another sense the period changed established ideas. Hither-to children making art had made recognizable pictures, models, prints – things directly related to equivalents in the adult world. Now children were beginning to make things only distantly – as yet – related to adult forms of art: ephemeral things, things that changed and grew and were destroyed, things that fitted into no accepted category, that were neither clearly painting nor sculpture, things made of useful materials that yet were useless. We can see now that the impulse to

14

make such things was also shaking the world of the professional artist; but in the early days the art teacher felt that he faced his problem alone.

In time, of course, when the two worlds met, the problem would be accepted as normal. In schools the problem was in a sense evaded. Teachers came to place even more emphasis on the activity, and evaluation began to apply principally to the activity – not always very critically: it is still widely felt that if you can say of a lesson 'the children enjoyed themselves' you have made an adequate criticism of that lesson.

It is perhaps interesting to note that Henry Miller is almost alone in suggesting that for the adult artist also activity has value, that the important aspect of an artist's life is not his 'accomplishments', his finished and perfect and dead works – the important thing is the process of creativity and the alive sensibility required by that process.

So, by the mid-fifties, in art classes in junior and secondary schools up and down the country, children were happily toying with all sorts of materials, and they and teachers alike were immersed in some at least of the problems inherent in such untraditional activities. Many teachers soon realized that new media might serve as a stimulus for failing interest or as compensation for lack of success in other directions. For many teachers and children during that period there was a great enthusiasm, an opening of doors, a fresh realization of true and genuine aspects of art.

It could not last; already the revolution has long lost its first glow; already – and perhaps this began to happen when the second generation of children entered upon the revolution – academicism is setting in. The discoveries that were so exciting in the first generation became the standard activities of the second. Teachers now do not quite so often say 'today we shall paint a picture': they are apt to say 'today I want you to see what you can do with these'. The difference is slight: the revolution is absorbed. Let us now look at one or two of the common procedures of the late sixties, and get a little more of the flavour of contemporary art teaching.

SOME COMMON PRACTICES

It is interesting to see that the 'subject' (as in the Victorian subject-picture) has survived all vicissitudes and is still firmly accepted as a starting-point right up to 'A' level. The literary notion of art that is implied seems to disregard fifty years of art in the adult world. No doubt the subject still persists partly because it comes from children as well as from teachers. From the day when the young child does his first drawing and is asked what it is, pressure on him is constant in emphasizing that a picture has a subject, in the first-stage sense: the picture is descriptive of something from life. His peers, his family, his teachers, all expect him to make a picture of something. Oddly enough, for young children the subject is important; the young child is not 'making art' but is using drawing – as he uses all his other activities – as a tool for exploring his environment and establishing relationships within it. Paradoxically, asking the young child what his picture is of tends to focus attention on how he has done it and whether or not it is recognizable; his attention is shifted, and the organic nature of his work fades. From then on the child begins to be conditioned to accept that making art is a school activity; and he finds that he is expected to continue making subject-pictures until he is eighteen.

The pioneers of 'child-art' were delighted to discover that children could paint pictures. Cizek, however, felt it to be necessary to keep control of what children did, or nonsense might result. Marion Richardson (1948) compared the paintings which girls did at home with paintings made in school, and went on, 'But in class the children turned to me for subjects. They welcomed an extension of their own experience . . . through a word-picture, they could reach towards the order, coherence and unity that belong to art.' From those early days onwards art teachers have felt that children were dependent upon them for stimulation, and that by giving a subject they could control development. Interest has, however, shifted away from picture-making; other materials and other

processes have long claimed the attention of the art teacher. So picture-making survives in a perfunctory form, a vestige of the past; embalmed, as we might expect, in the syllabuses of the examinations for the General Certificate of Education.

When new materials appeared in the artroom during the forties and fifties, teachers observed the genuine excitement, the sense of pioneering, the unity of intention which were generated, and realized that here was a situation which in their own terms had real educational value. They perceived that it was possible to re-create this situation to some extent by providing materials new to the class and saying 'here's a new material; find out what you can do with it' or 'find out what it will do'. Here was a new starting point for children of all ages, and a valuable one; but one not always used wisely. Upon it one might have expected that teachers would have built a sequence of events which would increase understanding and enable skills to develop commensurate with need – a programme which might with variations have been applicable to many situations. This has certainly not happened in any systematic way, though no doubt many teachers have encouraged development in various ways; but one feels that many children find difficulty in surmounting certain problems and get stuck at the same place again and again.

Of course the art teacher is in a dilemma here. By nature he distrusts systems, and thrives in the uncertain open-ended situation where he is called upon to respond to changing elements. Yet many art teachers, perplexed in their artrooms, were to show great interest in a system which came from outside – which was originally developed as a means for the initial education of the art student. This is the programme known as basic design; its originators recognized that changes in the world of art necessitated changes in the training of the artist, and accordingly developed a series of inquiries into visual form which operated through a process of isolating problems and devising exercises to explore them. These ideas have had a considerable effect on schools of art; and they have certainly persuaded many teachers in schools of general education to think again about what they are doing. Unfortunately the

exercises worked out by early teachers in the movement are only too susceptible of use outside an adequate context, and consequently have tended to be brought into the schools and imposed on children. Hence they are often meaningless, and cannot be fitted into a consecutive programme.

For the art teacher ideas of experiment and discovery go hand in hand. Experiment seems to mean trial and error learning – conducted normally in a casual and intuitive way far from precise scientific procedures. Indeed, even when methodical experiment (with glazes, for example) would seem reasonable, many teachers are unwilling to try it. To experiment often seems to mean to try something out and see if it works – not necessarily to try a number of alternatives; in this sense one sees that it means a suspension of judgement, an attempt to retain openness to experience, to whatever may happen. Such a way of working is clearly related to the procedures of the action painters; and perhaps owes something to Picasso's idea that each art experience must be a new one, that one must approach the making of each new work with a mind swept clear of the past. Yet the professional artist is already working in somewhat different ways; his procedures have become more analytic; the artist who is making a three-dimensional distorted box must know exactly what he is about. Once again we see that the influence exerted by the teacher may be potent in directions of which he is unaware.

Yet in other ways art teachers have been acutely aware of their influence. We have seen Marion Richardson giving a subject to the girls she was teaching. She would describe a scene; when her pupils could visualize it they painted it. Her part in the process was fundamental – she provided the bridge between life and art.

Later, art teachers revolted against being so indispensable; they saw the dangers; and many teachers, in giving to children merely a subject unannotated and unexplained, really felt that they were standing aside for an excellent reason – they were not coming between the child, his art, and life. So for many art teachers the process of teaching art became one of standing aside, of withdrawing. Nothing must be said or done

18

which would interfere. For many teachers this is still a canon. It is easy to see that major problems arise from such a stance. What is interference? If a pupil is in difficulties how is he to be helped? – for any help must in some sense modify the child's responses and actions, must influence both the activity and the thing made. Here is a crucial decision to be made; it would seem that art teachers feel that upon its outcome depends whether what is done by pupils is valid or not.

It must be noted here that the protagonists of basic-course ideas also start from the belief that personal expression is fundamental. What the pupil or student makes of his problem is his own affair: they are simply concerned to help him to understand what his problem is.

We must observe finally that a great many teachers are consistent to the end about non-interference. Not only do they believe that the child's activity is sacrosanct; they also believe that it is sufficient. The average art lesson begins with the initiation of activity; it ends with the clearing-away after that activity. It is assumed that children are capable of drawing their own conclusions from what they have done; that the activity is meaningful to them in terms of their own attitudes and understandings; that its lessons can be assimilated and put to use without further effort on the part of the teacher. Anyone who has seen the bewildered reaction to the teacher's encouragement of a pupil who has lost faith in what he is doing, or who has watched the mixture of chagrin and relief with which some children discard their work at the end of an art lesson, might well doubt whether this attitude of *laissez-faire* on the part of the teacher is not a serious shuffling-off of responsibility. One could not possibly doubt teachers' sincerity in their belief; but it seems more than possible that their priorities are confused.

ART IN EDUCATION

Let us recapitulate. We have seen that art first appeared in the schools in the unassuming form of drawing exercises designed

primarily to develop skills. Later observers saw that such exercises bore no relationship to the abilities of children as shown in their free drawings. There followed a new development of art lessons in which children were encouraged to make pictures in ways thought to be more 'natural'. Art teachers, responding to the vitality and freshness in the work of young children, sought to preserve these qualities as children grew older. Educationists, looking at this activity of making art, saw in it all kinds of values: art teachers themselves never lost sight of the fact that children were practising art. The introduction of new materials, the increase of three-dimensional work – these merely diversified the basic activity. Only as time passed the teaching-situation became formalized: teacher and children recognized their roles and played them. Did the influx of basic-course ideas have much influence? Is there still a strong ritual element in art-making in schools?

We have become so accustomed to the idea of the artist as the maker of works of art as saleable commodities, often expensive and to be preserved in art galleries; to the idea of art as spectator material; that we are inclined to forget that adult art has a function for him who makes it. This is partly because the Renaissance tradition of the artist as genius has all but convinced us that the artist is different from ourselves. Of course the great artist speaks for us and to us; but his is not a purely altruistic activity. He works because he must. Picasso said, 'Let it be understood above all that the artist works by necessity. . . .' Like all of us, he lives by working on his environment. His inveterate curiosity makes him try to see purpose and meaning in his world. He uses his art as a mode of thinking about and giving form to his experiences.

There are other modes of structuring experience: scientific, mathematical, historical and so on; corresponding roughly to subjects as taught in a secondary school (see Hirst, *Philosophical Foundations of the Curriculum*). Art educators believe that it is extremely difficult to grasp the inwardness of the aesthetic mode without experiencing it – without 'making art'. It is perhaps a truism to add that such experience is not likely to be of much help unless it is sufficiently 'deep'. That is why art

20

educators insist that the heart of any course in education concerned with art must be the practice of art.

But is that experience enough? It is one argument of this book that an overview of art education suggests strongly that it is not enough; that a true education will not merely enable children to 'think' in a subject, that is, to approach it from within, but will also help them to see it in the context of contemporary life, to begin to grasp how it organizes its material, what are its criteria, how it differs from and relates to other subjects.

There are many signs that we are moving into a period when education will concern itself with adventuring across the barriers that divide subject from subject in secondary and higher education. It will become the more essential for pupils to understand the structure and discipline of individual subjects. It will become of especial importance for the art teacher to realize that art has a place in the curriculum as of right, and not as some kind of occupation removed from the serious business of the school. In this sense it is important that art educators should thoroughly explore the problem of relative values in art education. We have seen that many different values have been – and are still – attached to tl.e concept of art in education. These may well have validity; but it is argued here that if we accept the idea of art education as being directed towards the understanding of art as a mode of structuring experience, then this acceptance immediately places all such values in a hierarchy. Creative activity, so often urged as the objective of art in education, is now seen both as the procedure of the artist and as a way of understanding that procedure. In this sense creative activity cannot be confined to the process of experiencing art by practising it, for the process of 'discovering about' art can also be creative. Thus the practice of art and the discovery of art should go hand in hand as one broad and unified activity leading to understanding in the twin senses of grasp and use.

We must go one step further and emphasize once more that the process of gaining understanding is not a brief one to be terminated when overt education ceases; nor is it an unim-

portant one, concerned merely with therapy or recreation or vocation. In a very real sense men attain their truest existence when they are working on their environment : the process of gaining understanding is necessary for life itself.

2
Making and Shaping

In this chapter we are concerned with the development of children in schools of general education, and concerned specifically with children and young people engaged in some form of art activity.

Ben Shahn (1957), wrote: '. . . forms in art arise from the impact of idea upon material'. By 'forms' he here intends to indicate not merely the general divisions of art into painting, sculpture, etc., but also those constituent elements of shape, line, colour, tone and so on which go to make up an individual work. He goes on:

> Form is the embodiment of content. Form is based, first, upon a supposition, a theme. Form is, second, a marshalling of materials, the inert matter in which the theme is to be cast. Form is, third, a setting of boundaries, of limits, the whole extent of idea, BUT NO MORE, an outer shape of idea. Form is, next, the relating of inner shapes to the outer limits, the initial establishment of harmonies. Form is, further, the abolishing of excessive content, of content that falls outside the true limits of the theme. It is the abolishing of excessive materials, whatever material is excessive to inner harmony, to the order of shapes now established. Form is thus a discipline, an ordering, according to the needs of content.

A key word in this quotation is the word 'embodiment'; form and content are not like bottle and liquid; in the work

23

of art, form and content are the same. The form *is* the content.

This does not prevent content from being complex. Content is present on more than one level – rather like one of those ivory spheres, carved and pierced, that has within it a smaller sphere, and within that yet another, and so on. For content may first be the overt subject of the work – a tale, an idea, a problem, a figure in a bath, an arrangement of geometrical shapes. Behind this is the artist's comment, his feeling about it, his reaction to it – here may often lie the original starting point for a work. Behind this again will be the artist's personality, the qualities and characteristics he brings to the business of art; these affect the whole work; we think of them as the style of the artist. Yet more deeply embedded in the form of the work are its universal implications, its generalized statements about life or humanity.

When we come to look at the work of young children it is clear that we see an ingenuous, intuitive expression of content in form. The content is evidently the material of their expanding experience of the world, and their need to establish their own place there. The form demonstrates clearly the search for relationships – the baseline, the exploded house, the vertical organization of distance, the comparative sizes of objects and people.

It is perhaps worth noting that young children draw upon both real and fantasy material for their pictures. The process of distinguishing between these is part of the apparent function of art activities for young children. Such activities are one way by which the child embarks upon the development and refinement of his view of the world; in this sense, however lightly and happily the young child appears to work, the activity is a serious one for him; through it his understanding of himself and his world grows.

This happy state cannot last. The child himself changes. The systems which he has been able to erect hitherto have been simple enough, immediate enough, for him to be able to attack them directly through the medium of drawing. But as he passes from childhood to adolescence – from Piaget's period

24

of concrete operations to the period of formal operations (Flavell, 1963) – the child passes beyond the business of simply trying to organize what presents itself to his senses; he becomes concerned with what might be as well as with what is. The resultant formal thinking, with its emphasis on analytical and deductive thinking, demands different tools. The old picture-making activity is no longer adequate by itself at this stage. It must take its place alongside other tools as the adolescent reorganizes his thinking to deal with abstractions.

At the same time the adolescent's means of responding to his environment and presenting it in visual terms develop new characteristics. Lowenfeld (1939) wrote of visual and haptic types; he thought of children forming two great classes: those who respond visually to life, like onlookers at a pageant; and those who respond by involvement; in imagination partici-pants. Recent research by Rouse and Witkin seems to suggest that these two classes are not so rigid as Lowenfeld thought, and that there is perhaps a third class, uncommitted visually or haptically, but able to respond in either way; and a fourth class whose responses are too negative to be typified. The first three classes are not rigidly divided, and may perhaps be thought of as somewhat mature in their responses. The fourth class seems to find difficulty in making responses at all.

It looks as though we need more information before we can proceed with assurance; but undoubtedly we can proceed tentatively to take certain steps by examining ways in which we may think of art for the adolescent.

First, Piaget's work has made it clear that there is likely to be a major change in children's ways of thinking somewhere about the age of eleven years, which will certainly affect their use of art activity as a means of exploring their environment. Since the trend of their work hitherto has been towards greater accuracy of statement, this change has usually been interpreted by teachers as having something to do with representation; and hence secondary art teachers have often enough assumed that their task at the secondary stage is to help children to see and represent accurately. In so doing they inevitably ran into difficulties, especially with children of haptic tendencies, and

25

also with those children of visual tendencies who were groping towards a more individual means of expression.

Second, we must observe that the difference between visual and haptic types is a matter of attitude towards the environment; that of the latter tending to be more subjective. It is essential, therefore, for the art teacher to be aware of these attitudes, since otherwise he will, as is suggested above, fail in his preparation for creative work to relate form to content in appropriate ways.

Third, we must observe that the young adolescent, in becoming more self-aware, becomes more consciously critical of himself and of his creative work. Thus, at the very time when for reasons of growth he urgently needs confidence, in his creative work he is undergoing a complex period of change which is most likely to be misunderstood. It would seem that it is at this time that the art teacher has most need to be aware that there is danger in seeking too far to influence the form of the work done by children.

Fourth, the principal positive step which the art teacher must take must relate to the possibility of loss of confidence on the part of adolescents. That this happens frequently is evident from the numbers of young people whose last memorable creative experience took place at the end of junior school or the beginning of secondary school. It would seem that if up till now children have been encouraged to work freely in their own way, at this period it is essential that they should be further encouraged to realize that there are many ways in which content can be given form, and that there is no greater truth in one way than another. This cannot be easy; a great weight of influences gathers in support of the belief that visual experience should be organized representationally. But if young people are to continue to experience art in a meaningful way the effort must be made. Perhaps the first steps should be made before and during those deceptive first two years in secondary school when children coast along under their own momentum, doing delightful work, and almost persuading the teacher that this kind of creative activity will never cease.

The fact is that at the secondary stage we must think first

in terms of young people's growing understanding of the relationship between content and form. At the time when they themselves are naturally becoming self-conscious and critical, at the time when they are developing ways of thinking analytically, everything is surely to be gained by using these characteristics, by asking them to look not merely at their own work, but at the work of their peers and of adults, analytically and critically. Only too often art teachers have aimed at preserving unselfconsciousness throughout this first part of secondary school; and perhaps most of us are guilty of attempting this through the typical art lesson: stimulation followed immediately by response. In a sense this has often appeared to come off: the work of children asked to make art 'off the cuff', without preparation and often without necessary factual information, may well look spontaneous; the truth is that it is generally superficial. Children used to working under such conditions develop routine responses; 'freedom' often conceals ignorance.

It must further be observed that in other ways also current procedures appear to militate against a true development of understanding of the relationship between content and form. First, and often, art teachers have tended to be more concerned with categorizing what is to be done by unfolding a technique. A teacher will begin a lesson by introducing a method of paper-printing. After encouraging the class to experiment for a while, he will expect the children to make a paper-print. Often he will 'allow the children freedom' to choose their own subject; on the face of it reasonable. Yet for most children such freedom at this point is meaningless, for they lack the drive to expression of the junior-school child, and having all the world to choose from, with what criteria do they choose?

Second, teachers are apt to give a subject to the class, and themselves decide what medium is to be used, on what scale, with what technique. Children who are able to respond to the stimulus offered must do so in the form decided for them.

If we accept what has been said earlier then we must feel that such procedures as these are closed procedures, offering no opportunity for children to examine the situation, and mak-

27

ing large and unwarranted assumptions. In the first case it is supposed that children have a stock of subjects on which to draw and will naturally know how to choose; in the second, the assumption is that the relation between content and form is so unimportant that one person can choose for another, and that the second person will learn from this something about art.

It would seem that if children in secondary schools are to be given the opportunity to work creatively in art, two conditions must be established, at least:

1 If choice is to be offered then it must be real choice, involving fundamental decisions, and not merely fringe decisions. Especially this must be the case where the relationship between form and content is concerned, since decisions here are crucial.
2 Children must have bases for choice. This means first that children must begin to understand the problems involved in their choices; this will inevitably involve a degree of self-consciousness. It means secondly, that they must have something to say : must have starting points simmering, crying for expression.

In respect of the last point, it is often assumed that children are empty of ideas, and that the teacher must supply them. He therefore takes over the task of providing stimuli – which may sometimes be appropriate and sometimes are not – and which often disregard the different backgrounds and understandings of teacher and pupil. It may be doubted whether children are so lacking in ideas; what is lacking may well be an appropriate trigger to release ideas. In this connexion, the teacher may have a role to play in bringing the environment to the artroom or studio, by organizing collections of material – some at least brought by children – objects of many kinds, pictures, maps, diagrams; by slides and films; by using television; by excursions, and so on – none of this intended to provide immediate material for expression, yet all of it offering source-material and relating to source-material already part

of the children's experience. Such a procedure might well activate children's imaginative perception of their environment. The more children could be involved in the whole sequence of events the more likely they would be to be able to make personal and individual abstractions from the material thus encountered.

Here now are two elements: children engaged in practical activity; an activated environment with children able to draw ideas from it. In the context of our present discussion, at least one more element is needed: a growing understanding by children of the kinds of decisions they must make, and of the kinds of criteria they must use in so doing.

This would seem to demand a more systematic approach than is as yet the case. Art teachers do a great deal of individual teaching, and undoubtedly some of this has to do with understanding 'why' as well as with 'what' and 'how'. In so far as what is said is tuned to the comprehension of the individual boy or girl, this is an admirable way of teaching; its weakness is the difficulty the teacher experiences in remembering what he has said to each child, and the consequent problem of building up with each child a developing sequence of ideas. It seems evident that further means, beyond teaching related directly to doing, are needed. If we now consider this matter in relation to the necessity (already discussed) of ensuring that children understand that there are many ways of giving form to content besides representation, it is clear that here is enough matter to give shape to a whole interlocking series of practical lessons, discussions, visits, sessions of looking as well as doing, collecting, collating and so on. It must again be emphasized that what is visualized is not a procedure for helping children to make better art (though this might well happen); it is a procedure for helping children to understand art better.

It is possible, therefore, that only seldom – if ever – at secondary level might the art teacher find the need to conduct an old-style art lesson with its subject, stimulation, and immediate response. Instead, he would be devising a course leading to the true freedoms of creative work, so that the

shape of lessons for individuals or groups might vary widely according to the kinds of problems which were being tackled. We have learned that fruitful work can be brought about by isolating problems or aspects in art, and there seems no real reason why this process should not be used with children during the transition period before and after they enter secondary school; but we must make certain provisos: one, that children must from the very beginning play their part in devising sequences for themselves; two, that they must at all times be helped to see the relevance of what they are doing. By these means the situation would be avoided in which children are asked to carry out exercises meaningless to them, and in which the exercises relate only to one kind of art form.

We are brought face to face with the problem of quality in children's work. The art teacher – in junior or secondary school – is bedevilled by the need to have his children produce 'good' work; for display, for speech day, for examinations, for whatever else. He may often feel that if the children's work is 'bad' then he is not doing his job properly. Much of the confusion derives from our failure to identify our aims clearly enough. We have become so involved with practical art that we sometimes half-believe that we have to produce art. A good deal in fact of our teaching is directed to this end. If we can accept that art in the schools is a means and not an end (as indeed it is for the adult artist, as Henry Miller has said) then immediately the situation is clarified. We accept what children offer us, if it is a step in a sequence; while, if the sequence is a meaningful one for the pupil, the work will be meaningful in the terms of the sequence anyway. The criterion is no longer the bald one of artistic quality; but, paradoxically, if this is not what is aimed at, it is perhaps the more likely to be achieved.

On this question of quality one more thing needs to be said. Children, feeling their way hesitantly or surely towards an intelligent understanding of art, may not proceed directly to it. They are likely to deviate, to explore byways, to make mistakes, to wander into dead ends. Even the professional does this – to do it is an essential part of learning. Certainly

the art teacher has a duty not to allow the individual to wander off without advice; but true understanding does not come merely as the result of good advice. Maturity has to be lived into. It may require a great deal of patience and for-bearance on the part of the art teacher in dealing with children who move slowly. Also, the future of this path is not crystal clear; by the end of their school-days children will certainly reach different points along it.

Finally, one last word on content. When an art teacher says, 'today we are going to make a painting of Joseph and his coat of many colours', he is assuming that the tale to which he refers makes an appropriate starting point for a painting by all the children in his group. But not all children may see it that way. Creative response may take many forms, and a starting point which stimulates one person in one way may have a very different effect on another. As yet our education does not provide adequate means of moving from one art to another.

We should recognize, too, that our current procedures con-dition children's responses in a fundamental way. If the de-cision is made by the teacher that a certain stimulus must lead to a particular response (that is, in paint or clay or whatever) the children are losing a basic freedom of choice which they once had as small children. Without this choice, children can only respond in a ritual way; they should never have lost it.

CREATIVITY

The words 'creative activity' have already appeared frequently in this text, and it is time that we looked at current ideas on creativity. Twenty years ago practically no work had been done on the subject; and although we used the word in relation to activity in art, we used it vaguely and imprecisely. In fact, of course, we still use it imprecisely, and still have vague ideas about it; some art teachers still feel that this is a matter into which one should not inquire too closely, lest one tarnish its perfection. Yet a great deal of inquiry has gone on, mostly in the United States; and although this is still chaotic and inade-

quate, concepts and models have emerged which shed a new light on many of our current practices in art education. In this context I wish to look at two elements from the mass of material which is available: first, what Guilford calls a model of the sequence of events in creative behaviour; and second, the cluster of abilities which the individual must particularly deploy in creative activity, and which Guilford has now brought together under the heading of divergent-production abilities (Gowan, Demos, Torrance, 1967).

First, however, perhaps one or two general points should be made.

Although most current attempts to define creativity are in terms of process, it is important to recall that an essential element in creative activity is an end-product. Bruner says that creative production must be 'effective'. Further, the thing made or produced must be a new thing – presumably new in the context of its time and milieu. It would be a mistake to continue to suppose, as has often been done in the past, that creativity is the special province of the arts. Indeed, much of the current interest in creativity in the U. S. stemmed from the need to stimulate creativity in scientists. Mathematicians and scientists have contributed to the total picture of creativity as a chronological process at which we are about to look.

On the whole we tend to assume that there are few highly creative individuals and many non-creatives: it is more to the point to say that there is very little scope in our educational system for individuals to behave creatively; this is almost as true of the arts and sciences as of other elements in the curriculum. We must look in this chapter at some of the ideas of those writers who believe strongly that it is possible to provide a more favourable climate for the development of creativity, and that if we were to do this many more children would behave as creative individuals.

The chronological model of creative activity

There have been many descriptions of the sequence of events in creative problem-solving, of which that of Graham Wallas

provides the standard model, while that of Poincaré, the French mathematician, is one of the most illuminating the latter reported at length in Ghiselin, 1952). Poincaré describes in the most lively and human detail the various stages through which he passed in discovering and assembling a new set of mathematical theorems: the identification of the problem; the prior work upon it, apparently fruitless, yet seeming partly to clarify it and partly to eliminate many false avenues; the period of uncertainty and maturation, of unforeseeable length, during which it appears that the unconscious mind works upon the problem; then the unexpected flash of insight, the discovery; and finally the rationalization, the verification, the writing-up of the problem and the solution. Wallas and McKellar (1957) describe the same four stages; preparation, incubation, illumination, verification. Dewey's and Guilford's are rather more complex but follow the same lines, as do a number of others.

There are a number of points here which are of interest to art educators:

The first is the period of uncertainty and effort. Poincaré describes how without success he attempted to solve his problem rationally, how he was left after a great deal of work in a state of dissatisfaction. He leaves one in no doubt about the amount of work necessary in identifying the problem and in its preliminary exploration. Clearly for him there was nothing easy about this part of the task, nor about the period of uncertainty which follows it. Psychologists who have studied the make-up of creative persons suggest that they are not disturbed nor made anxious by such uncertainty, seeing in it possibilities for new combinations.

The second point to observe is the uncertain duration of the waiting period; which may not be hurried on nor delayed by conscious means. Since the artist, in the making and completing of a single work, may encounter many problems, it is clearly difficult accurately to forecast when a piece of work will be finished.

The third point is that one must have faith in the solution when it presents itself. In the artistic process the verification

consists in the assimilation of the solution in the work; but this may well lead to changes and developments elsewhere; the working out of a complex system of balances. The process of adjustment is clearly a further problem.

The final point for us to consider relates to the completion of a piece of work. For the artist there is no one right solution to any of his problems. As we have just seen, one solution leads to a further problem, and so on. But each problem must be dealt with in the knowledge that there is to be finally a whole thing to which the solution will contribute; the artist's problem is not one but many, yet the many are part of one problem.

Any description of the creative process in terms of a sequence of events must be of interest to the art teacher, since we believe that our concern is for creative development. Yet it is immediately apparent that in important respects the descriptions conflict seriously with normal practices in the art-room or studio. We must consider these points in the context of the secondary school.

First, as we have already seen, it is common practice for the teacher to provide some kind of stimulus, to which the class or group are expected to respond – if not immediately, then certainly well within the same double period. This presumably means that for certain pupils the teacher's introduction uncovers the problem and presents it in such a way that insight suggests a solution. But for all pupils? Experience indicates that a great many children either learn to produce stock responses or learn to avoid making any response.

Second, it is generally held that the art lesson must be 'fun', that the pupils must 'enjoy' it. (Often, to hear teachers talk, you might suppose this the only criterion.) It is generally maintained, too, that children must be successful, that things must go smoothly. Now, one characteristic of the creative process as described by Poincaré and others is certainly that the process is arduous and uncertain, and that work is needed which must go unrewarded at the time; one needs to be able to hold on – to persevere – to be patient and let matters develop and mature. We know from our own experience how true all

this is. Certainly the practice of art is enjoyable – but surely on a deep level; one would not be doing anything else, but how one longs for a little superficial success! It would seem at least possible that in encouraging children to suppose that the process is easy, we do art a disservice; there are other ways of encouraging them, without misleading them and depreciating art.

This is perhaps the place to report that there are many descriptions of children who have in their creative efforts met with encouragement; who have been inspired to persevere; who have gained great satisfaction from their work; and who have in certain respects been transformed by their success. These reports seem to indicate that encouragement of the right kind by the teacher reinforces interest and enables the pupil to over-come difficulties (Gowan, Demos, Torrance, 1967).

Abilities deployed in creative activity

Between 1950 and 1957 both Viktor Lowenfeld and J. P. Guilford (reports by both in Parnes and Harding, 1962), unknown to each other, were researching into creative activity; the former looking into differences between more and less creative people in the arts, the latter trying to find out what makes scientists and engineers creative. When they eventually came to compare their work, they found that each had come up with a number of abilities (Lowenfeld called them 'criteria for creativity') and that there were remarkable similarities between the two lists. Lowenfeld wrote, '. . . there is a strong thread of creativeness which links all fields of human endeavour'.

Since Lowenfeld's list is longer, and was originally formed in relation to the arts, we shall use it as the basis for this discussion; Guilford's list of divergent-production abilities is shorter. It must, however, be emphasized that we are talking about abilities which appear in all kinds of activities – not merely in the arts and sciences.

1. Sensitivity to problems Both Guilford and Lowenfeld place

35

this as a specifically differentiated ability first on their lists. Lowenfeld wrote, 'no creative work is possible unless it is based on a sensitive experience'. He was at pains, too, to emphasize sensitivity to the problems of other people – a social sensitivity. He clearly felt that in the arts one arrives at one's starting point for practical work through the senses, and that therefore this is the place where the teacher's work starts. We do not all have an equally sensitive awareness of what is happening round us; partly at least this is because our senses are not all equally developed, nor are they developed in a balanced way. Moreover we develop the habit at an early age of seeing what we want to see and what we expect to see. This is tied up with the use we normally make of sensory experience; to find our way about and to perform our normal tasks we rapidly develop a selective 'vocabulary' of information. Unless some incident occurs to shake us out of what we think we see, we continue to live with our formalized view of the world. It is important to note that to change this state of affairs requires more than just 'looking properly' at things. Our understanding of what we see is very much a matter of translation by the brain not of a picture in the eye, but of a pattern of nerve impulses; to develop our understanding involves learning.

But to have, or not to have an awareness of one's surroundings is more than a matter of seeing them properly, important as this is. One's attitudes are also involved. One must be interested. This carries implications of being open to new ideas and experiences, of being ready to think beyond the stereotyped response; and this again is related to the personality – the maturity and stability – of the individual. Above all, curiosity is needed. To become aware of open-ended elements in one's environment demands more than interest, though this opens up a situation; one must wish to find out more, to understand.

It is interesting to ask how far art education appears to be concerned with the development in its pupils and students of this sensitivity to problems from which so much else would appear to follow. Undoubtedly we have been much occupied with problems of perception, though this has perhaps tended to take the form of attempting to teach children to 'see what is

36

there' as a kind of datum of information on which to build; when possibly it would be of infinitely greater use to help children to realize that there are many ways of looking and many ways of seeing. We have, too, been concerned with the idea of awareness. Yet on the whole art teachers have felt that it was their duty to select problems for children; not only through choice of subject, but through choice of medium also. Of course there are times when the teacher must intervene; but it would seem that more could be done, in a more systematic way, to help children to organize out of the chaos of sense impressions some order, some priorities of interest, and to relate these themselves to expressive or exploratory procedures. Education in this area of experience would appear to be fundamental to individual creative activity.

2. *Fluency*　Fluency of ideas appears on both Lowenfeld's and Guilford's lists. Guilford was naturally more concerned with verbal fluency, and gives four kinds of fluency for which he devised tests. They are Word Fluency – the ability to think of words which satisfy some given requirement; Ideational Fluency – the ability to think rapidly of words in a given category; Associational Fluency – the ability to list words having some relation with a given word; and Expressional Fluency – the ability to place words into organized phrases and sentences. One can readily adapt these subdivisions to art, and see for example, how essential it is for the painter to have alternative ways of applying paint to achieve variety of surface, or to be able to see what are the possible alternative courses when a decision has to be made at some point in the development of a piece of work. Many children have problems with fluency : their ideas settle, become rigid; the work takes a certain course and the pupil cannot see a way out. Discouragement is inevitable. The child here seems unable to be sufficiently fluent to see or experiment with alternatives, nor sufficiently flexible (in terms of the next ability to be discussed) to re-adapt to the new situation and build on it. What seems to be needed in such a situation is the suspension of judgement, the ability to play

with possibilities, to produce many variations on the basic theme.

It should be noted here that this ability of fluency has little to do with the way in which young children repeat a formula. This is part of the process of learning and should not be discouraged. Moreover, perhaps this very repetition is part of the process of developing fluency, which shows itself in other ways at this time, especially in the uses made of materials for expressive purposes. It is at the secondary-school stage that difficulties seem to arise, perhaps partly because of the prevailing junior-school emphasis on neatness and accuracy, which must encourage conventional responses and inhibit experiment. There may well be a case for art teachers to devise ways of giving opportunities for children to be fluent in a situation in which there is no penalty for mistakes or guesses.

3. *Flexibility* Flexibility, which appears on both lists, is defined as the ability to adapt to new situations. In art the pupil, like the artist, is continually faced with a recurrent problem: everything he does changes the work, which thus continually presents a sequence of new faces, asking for reassessment and decision about the next step to be made. We must not underestimate the complexity of this whole process, which here we must observe is involved with ideas about the direction of development of the work as a whole. This is the area in which pupils at the secondary stage find real difficulties, because often they build up preconceived notions of what the end-result will be, and these ideas tie them down so that they are unable to respond to the thing they are making as a thing in itself and can only see that it is unfinished. This should of course be only a phase in the growth of the individual's understanding of art activity; perhaps related to the appeal to visual observation which is so normal among teachers at the secondary stage. If you intend to try to produce a photographic image, then not surprisingly you feel that you know what it will look like. Perhaps, however, the ability to adjust to the changing work should never be lost; most young children have it and exercise it with their natural liveliness – often, indeed, being so flexible

that the subject of a picture may change half a dozen times in its short life!

4. Originality Originality appears naturally on both lists. Lowenfeld describes it as the ability to 'give *uncommon* responses to questions, and *unusual* solutions to problems'. Guilford speaks of the ideas generated as 'new, to him and perhaps to his culture'. Evidently an original person in this sense is one not dependent upon the ideas of others but able to generate his own criteria of ideas as they come to mind. It seems, therefore, that such a person is profoundly able to be true to himself and to his own creative processes. Originality appears, therefore, to be at the centre of the cluster of abilities which we are considering. One can see that in these terms it is possible for all children to be true to themselves at their own level of originality, and one can see how the self-rewarding activity of art can be a potent means of encouraging and bringing to light such integrity.

5. Ability to re-define and rearrange This ability – and those that follow – appear only on Lowenfeld's final list, though Guilford writes that he and his colleagues considered them as 'possibles' at an early stage in their inquiries. It is not surprising that Lowenfeld retained in his analysis this ability to see a piece of stone as the embodiment of an idea, to see that scrap-material may take its place in a piece of collage, to perceive the ambiguous nature of the image in much contemporary work in art; it seems fundamental to the activity of making art. Children have this ability from a very early age : objects do not yet for them have those fixed and limited uses that they have for adults. Young children can make use of anything that comes to hand and pretend that it is almost anything else. This ability is speedily driven underground in most children; to be able to use the right thing at the right time is taken to be one mark of an adult. This may be a contributory reason why so many adults find it difficult to 'understand' art. However, in the last twenty years some generations of children have collected scrap-material to make collages and montages. Perhaps they

39

will understand better than earlier generations; and perhaps if the whole matter were made explicit as part of children's learning about art this fundamental problem would be greatly diminished.

6. *Analysis* In the end Guilford abandoned this as a specific ability, saying that 'each person is not at all uniformly able to analyse in all situations . . .'. Lowenfeld thought of analysis as a process of abstracting details, and wrote that creativity would be impossible without 'abstracting from generalities and arriving at specific relationships'. The matter is partly one of perception. While adults, looking at a new thing, see first the outline and then the details, young children tend only to see that about an object or person which will identify it in the appropriate context. It is not surprising that the young child's symbol for a tree is (as many grown-ups say) a toffee-apple on a stick; the circumstances under which the child encounters the tree are not often sufficiently critical for it to be necessary to observe more. Perhaps too here Lowenfeld reveals himself as the child of his age: he lived through a period of interest in detail and in texture; none the less, his general argument is useful, and it is worth noting that although Guilford discarded the idea of analysis as a separate ability, he does include an ability called elaboration, which has to do with planning and with relationships between wholes and parts.

7. *Synthesis* 'The combining of several elements to form a new whole', writes Lowenfeld. Guilford rejects synthesis for the same reason as analysis, that not everyone is able uniformly to synthesize in all situations. Nevertheless, all art is brought about by a combination of re-definition and synthesis. Even if Guilford is correct, Lowenfeld's instinct led him to point in a direction important to the art educator.

8. *Coherence of organization* Here, of course, is Lowenfeld the art educator again, writing not of an ability but of a principle – the principle by which the artist arranges his elements to form a unified and satisfying whole, in which every-

40

thing has its place and nothing is unnecessary. Lowenfeld writes of 'a continuum with chaos at the lower end and the most complete harmonious organization at the upper end'. He also thinks of the 'striving for higher forms of organization' as concerned not only with the elements of art, but also with 'a more complete integration of thinking, feeling and perceiving'.

Lowenfeld would appear, in writing of the principle of coherence of organization, to have been thinking in terms of the evaluation by the artist of the actions taken by himself in creative activity. Guilford mentions evaluative factors, but without going into details. Clearly in the process of making the work, which grows and changes at every moment, the artist must constantly be making decisions relating to content, to its embodiment in the work, and to the development of the work as a thing in itself. These decisions, it must be emphasized, are those of the artist himself, and upon them depends the whole tenor of the activity in its movement towards completion.

The whole area of evaluation in the arts is one so far not explored very systematically, and there is practically no material to which reference may be made. This is not very surprising in view of the obvious difficulties, but it is unfortunate, since the process of evaluation must occupy a key position in any assessment of the creative process.

It may, however, be useful to look at some aspects of evaluation a little more closely. Let us first look at what happens when young children practise art.

If one watches a child of pre-school age drawing on scraps of paper, one is struck immediately by the response to the shape and size of the paper. In the same way Desmond Morris was struck by the way in which Congo, a chimpanzee, showed a marked response to pieces of card which had lines or shapes already drawn upon them (Morris, 1962). If we can accept that there is an element of judgement – not necessarily conscious – in these responses, then it looks as though evaluative processes develop at a very early stage. Nevertheless, when we think of ourselves engaged in the activities of art, as adults, we surely have to admit that our actions and decisions owe a great deal to experience: to practice, in the sense that we have en-

41

countered similar problems before; and to our knowledge of art. In other words, whatever intuitive wisdom in the arts one is born with, is modified and developed by our experience and our environment. This is of course the 'nature-nurture' controversy, still quite unsettled. Since there appears to be a considerable support in the U.S. for the belief that there are teaching processes which will help to develop creative abilities, it would seem that we must take a middle line in this argument.

Practice in the arts is not merely a matter of practising in order to acquire or strengthen a skill; it is more a matter of deepening one's insights into what one is doing. The artist 'thinks' in his medium, and the 'thoughts' with which he deals are the qualities of the material as it achieves form. The procedure is what David W. Ecker, in a most stimulating article reprinted in *Readings in Art Education*, calls qualitative problem-solving. We have already considered the process of creative activity as a process of moving from one problem to another: the solution of one problem creates or makes clear the next – all this within one piece of work. But one painter quoted by Ecker, Yasuo Kuniyoshi, thinks of this sequence as stretching over years; he sees the artist taking a problem and attacking it in a number of pieces of work; he then says, 'Once accomplished to my satisfaction, however, it becomes an integral part of me, enabling me to go on to another problem'. This emphasizes a process of development on the part of the artist; it is not that his works become better or worse – that is irrelevant – it is that he himself through experience develops and changes. The emphasis is squarely placed upon the person, not the thing.

The question still remains: how much practice? Of course in one sense the answer is simple – a lifetime is not enough. Nor can one visualize it as ever being possible to say of any pupil: this child has had enough experience of art. Therefore for many years it has been urged that children cannot do too much practical art; every art lesson is, therefore, crammed with practical work – so that practical preparation and clearing away are often done before and after the lesson. The children like practical art every week, too; but is it adequate?

To this question on a two-pronged answer might be given.

First, one must make the point that to engage children in practical activity with art-materials is not necessarily to engage them in worthwhile creative activity; and, going further, one would have to argue that much of what goes on in art lessons is so trivial as to depreciate art in the eyes of the children. In other words, the best use is not yet being made of the time that is at present allocated to practical work.

Second, one must relate means to ends. The practice of art is worthwhile for its own sake; but there is evidence that simply to practise art in school is an inadequate initiation into art as it exists in the adult world. To enjoy the arts fully as a human phenomenon one needs to be able to approach them philosophically, critically and historically; and it is simply not true to suggest that such studies do not enhance most people's enjoyment. The arts speak to the maker and the spectator with their own voices, but to understand demands more than native sensibility. Especially is this true, for example, of contemporary art; the outsider, unaware of the history of art since Cezanne, finds the task of attuning himself to contemporary forms impossible. How many adults who 'did art' at school would confess themselves at a loss when faced with contemporary forms in the arts? A *questionnaire* given recently (Mather, unpublished DAE thesis) to a small number of students entering a main course in art in a college of education seemed to reveal an abysmal ignorance of facts about art and a very real lack of understanding of art; and these were young people who had taken G.C.E. art. What would we find if a similar *questionnaire* were administered to young people who gave up art at thirteen?

THE TEACHER AND CREATIVITY

We must now take a longer look at the classroom and artroom situation in the light of what we have been saying about creativity. One thing should be said at once: that teachers of art to children of all ages would claim that they are now – and have been for many years – deeply concerned that the children they teach should have creative experiences as they work in art. Yet it is clear that the kind of creative situation described

43

by Poincaré is not often reproduced in the classroom or art-room, nor does the common situation enable or encourage the deployment of all or most of those creative abilities which we have been discussing. How has this happened?

First of all the descriptive models laid out by psychologists and others have not been readily available to art teachers in this country until comparatively recently; and very little original research has been done in this country on creativity – which, indeed, as a psychological concept has had difficulty in making its way here. Few art teachers have analysed what they meant by creativity – few in their thinking have gone far beyond the idea that creativity consisted in making something new, and that in the making the whole person is employed. Second, Cizek and Marion Richardson developed teaching techniques and variations of them spread rapidly. These two reasons appear to be adequate for explaining how it was that until Victor Pasmore took a new look at the process of teaching art, only one real innovation had been made – the idea that the materials you use might themselves become your starting point.

It would be a mistake to suppose that we have now got blueprints for art lessons; the matter is far too complex for that. There are, however, certain pointers which we must now take in order.

First, it would appear that a starting point ought properly to lay out a situation in which the individual can discover the problems which interest him. The developmental sequence here should be one which gradually clarifies the situation and gives children increasing responsibility for distinguishing their own problems and exploring ways of solving them. One can see why basic-course exercises have not transplanted well: teachers are apt to select the problem and explain the means; for the child there does not even seem to *be* a problem – he only has to do what he is told.

One can see that the process of developing sensitivity to problems is an essential element in differentiating out art as a mode of organizing experience. The child has to learn the kinds of problems which are appropriate; it must be possible for him to push off in 'wrong' directions (if there are such) if he is truly to

44

explore the boundaries of what is art.

Second, it would seem that materials and techniques should be at the service of the child. Of course if the teacher says 'Now we are going to make a painting' this adumbrates an area in which problems are to be found; but unless this is intended it appears likely that the materials required would not normally be decided at so early a stage in the process. Trials might be necessary with a number of media. Possibly a form of development might be towards isolating a problem imaginatively in terms of a medium.

Third, it is clear that often the process of recognizing one's problem will lead directly into attempted solutions. We must be aware that a piece of art is complex, however simple it may appear; that in dealing with a problem a solution may come, not in one step, but in a number of steps. A single problem can be the subject of a simple or a complex solution. It might be that one starting point would involve preliminary work in separating out and dealing with a number of problems; or that a problem might present itself as complex, only to be revealed when successive appearances are peeled away as simple after all.

Fourth, it can be seen from our picture of the developing process how essential to it are the twin abilities of fluency and flexibility. One sees, too, that even more crucial than these is the sensibility which enables the continuous necessary evaluation to proceed. At every step sensitive evaluation is the condition of the next step. A great deal of wise and restrained teaching will be required if pupils are to learn how to be consistent in their response and art at the same time to retain some confidence in their ability to judge and make decisions on the basis of their own judgements. Art teachers ought to be well-accustomed to this problem; if they would help pupils to be aware of the separate and recognizable steps in the process, their task would grow easier.

This spotlights the fifth point that must be made: the pupil operating as artist must 'think' in his medium; his subject matter is, in Dewey's words 'the qualities of things of direct experience' (Dewey, 1934). Yet the teacher must communicate with the pupil in words. Both must be aware that words stand

in one relation to experience, the forms of art in another. Neither teacher nor pupil can do without words, and a great deal of refined and precise thought can go on in words about experience in art. This process of analysis and description of artistic activity is an essential one if art as a mode of organizing experience is to be related to other modes; but it can only be meaningful for most people if they have 'experienced' art. We must emphasize again that by this general statement it is not intended to suggest that first the pupil gets his experience and then passes on to theory. Art teachers are already used to relating the work of the pupil to work by adult artists, and to using philosophic and critical discourse at a level appropriate to the work and to the pupil's understanding. This interlocking of experience and discourse would seem to be an essential element in the growth of children's understanding of art. What we are concerned to do here is to shift the emphasis and the balance, to ensure that another paradox of art operates and that the self-rewarding activity becomes also a means to an end.

3
Influences affecting art education

Ideas in art education change, develop, become modified, in response to pressure and needs from inside and outside the field. However much educationists may feel that they are in some way leading society, in a more real sense they are only doing what society needs – and permits – them to do. Thus the beliefs and attitudes of society towards the arts and towards education become important to us in our present inquiry, in order that we may understand how our present ideas and actions in art education have originated and developed, and may see in what ways development appears possible in the future.

VOCATIONAL ART

In the *Saturday Magazine* for November 1842 appears an article on The Influence of the Arts and Sciences. In it the author remarks:

> the fine arts are the methods by which our physical and animal sensations are converted into moral perceptions . . . in their different ways they are all valuable . . . the arts of poetry, painting, music, sculpture, ornamental architecture, gardening, with many of the products of literature and imagination, supply an inexhaustible fund of recreation and enjoyment, that have no counterbalancing pains. But, [he goes on triumphantly] it is the science of our era that is its pride and its boast.

Here is one statement – embodying a rather odd and revealing list – of an attitude towards the arts and a notion of their purpose; at this very time 'linear drawing' was included in the curriculum of the British and Foreign Schools Society, Schools of Design were being established in a number of provincial towns, and Training Colleges were being encouraged to teach drawing. These practical moves were being made in response to needs quite other than those implied by the *Saturday Magazine*. The weakness of design among English manufacturers had become noticeable, and a Select Committee of the Privy Council on Education had reported that 'the principles of design should form a portion of any permanent system of national education'. In practical terms this meant that children should draw; for vocational reasons. Accuracy and perfection were the objectives, precise methods were developed.

We shall look again later at the whole problem of design. For the moment our concern is with the idea that through a course of practical drawing children could be directed towards a mature sense of design. There was clearly in the minds of the promoters no conception of children other than as raw material for developing certain skills. There was certainly no idea that children might have some contribution of their own to make. Here is one strand which has become woven into the fabric of art education in this country; and a potent one, since it was first in the field.

Yet it was not long before other ideas began to appear. As early as 1861 J. Snell, a schoolmaster, had his doubts about the whole thing.

Drawing, [he wrote (in the Newcastle Commission's report)], should be regarded as a special and extra subject of instruction . . . of what value is drawing to the agricultural labourer, the shoesmith, tailor, butcher, baker, sailor, small farmer or little shopkeeper? If for training of the hand and eye, as is sometimes said, it is plain enough such hands and eyes will require a very different training; and if for the mere cultivation of taste, I think this may be accomplished without a course of instruction in art. . . .

Spencer and Ruskin, too, both had serious doubts. Neither had much use for the policy of the Government schools on drawing; Spencer because he thought it all dry as dust, mistaken in omitting colours from primary exercises, and too concerned with the finished drawing – 'the question is not whether the child is producing good drawings; the question is, whether it is developing its faculties . . .' he wrote in *On Education* in 1859; Ruskin because he felt that it was a mistake to assume that human beings could draw mechanically. Young children, he felt, were best left alone to 'scrawl'; older children should be referred to nature; the final exercise proposed in his book is 'Copy a stone from nature' (Ruskin, 1857).

The tale of art education in England during the nineteenth century (told in detail in *Artisan or Artist?* Sutton 1967), and indeed on into the twentieth, is a tale of gradual modification and development; but through it all persists the belief that through exercises and practice the child must learn to draw; and right on into the twenties and thirties the emphasis in elementary schools lay on the acquisition of skill, and in the background lay the shade of art for vocational reasons.

LIBERAL EDUCATION

The concept of a Liberal Education is one that has engaged and confounded educationalists in Western Europe for years, and in this country particularly since the days of Cardinal Newman. By the middle of the nineteenth century – whatever the earlier significance of the phrase – it had come to mean a classical education with cultural value. By the end of the century it had taken on new ideas: a tendency for the division between culture and utility to become less clear; the bringing together of arts and sciences in a balanced curriculum; and finally the revolutionary suggestion that English studies might replace Classical.

Newman wrote of his liberally educated man: 'he apprehends the great outlines of knowledge, the principles on which it rests . . . a habit of mind is formed . . . of which the attributes are freedom, equitableness, calmness, moderation and

49

wisdom. . . .' In our own day R. S. Peters has spoken of 'cognitive perspective' – the power of seeing knowledge as a whole, and of assembling a personal picture of its inner relationships.

Ruskin, on the other hand, gave a central position in his notion of a liberal education to art, music and literature. When we look at his ideas in the context of the discussion on liberal education during the eighteen-sixties, his linking of the arts with moral education does not seem wholly out of place. 'Education,' he wrote, 'does not mean teaching people to know what they do not know. It means teaching them to behave as they do not behave.' He therefore wanted pupils in schools of general education to 'have experience of the finest music, art and literature'. He thought that art should be made a subject for university undergraduates; he himself taught art in the London Working Men's College. He believed in the revival of handcrafts. His writings played a part in the turning away from vocational art towards what was thought of as the 'natural' development of the child's abilities – notably through his influence on Ebenezer Cooke – and his ideas on the inclusion of art, music and literature have borne fruit in many ways since then, as most of us could testify from our own experience.

More broadly, the concept of a balanced curriculum as one element in the ideal of a liberal education undoubtedly strengthened the hand of those educationists who looked towards the arts in education as something more than vocational. Perhaps, though, we should note here that the battle for vocational art was always, one feels, a losing one, because the matter was never properly thought out: vocational training in art was not planned to lead to a specific work-situation.

In later days it would appear that from the idea of a balanced curriculum derives the not altogether happy idea that the arts in education are no more than balancers; occupations for re-creative periods for pupils whose real effort is applied in other classrooms. One encounters in many connexions the notion that the arts offer a 'soft option'; the idea is by no means dead today, and has all too often found credence from the activities of art teachers themselves. Yet the original idea of balance surely implies a truer comparison between forms of study than

50

this; the value of the contribution which the arts make to education is not to be measured by primitive notions of what is or is not work.

CHILD-CENTRED EDUCATION

John Dewey, philosopher, psychologist and educator, was in his last role particularly concerned with the idea of growth. He conceived education as playing its true function in enabling the individual to grow harmoniously with the society in which he lives. He therefore thought of the school as a miniature community, in which real-life activities could be explored; from these explorations would develop more formal studies, which might in time (e.g. possibly during the secondary years) correspond with the subjects thought of as divisions of knowledge. It is this idea which is taken elsewhere in this book as a formal exposition of the unity of studies in art education.

Clearly Dewey was concerned with the pupil in the present; he felt that the teacher's constant care must be, not some imaginary finished product in the future, but the living pupil in the context of his current life at school and at home. Thus external standards are irrelevant; each pupil sets his own standards by his ability and situation.

The teacher, Dewey believed, must act out a positive role: he must arrange for the kinds of situation in which children's natural interests can find scope. He should not, though, at this point stand aside. He must have ideas about the course of study through which the activities of children may move purposefully. He must endeavour to see a more complete picture, and place his ideas for educational activities in the context of society.

Through what we all know as the project method and from the Dalton plan Dewey's ideas spread widely and beneficently. Only they changed somewhat in the process: the self-realization of the individual became an end, not a process, for many educators, and it is this aspect of Dewey's ideas which particularly influenced generations of art educators, rather than the social implications. It is easy to see why. The practice of art is

after all a self-rewarding activity, and once the vocational purpose diminishes in importance and the response to children's art develops, the idea of the boy or girl making paintings or pottery 'for themselves' is an easy next step. One can see, too, that art teachers, valuing above all the freedom which their study of art gave them, readily took the step of placing additional responsibility on the shoulders of the pupil, or, as they themselves might put it, giving him more freedom. Indeed, as we have seen, this notion of freedom became in the eyes of art teachers more important than anything else, so that Dewey's idea of the positive role of the teacher tended to be forgotten.

Because of the immense influence which Dewey has exerted on art education in this country, it is important to reiterate that in art education his ideas have not yet been fully implemented. He envisaged a controlled situation, in which the teacher had an over-all picture of what was happening and what might happen. The art teacher, bedevilled by traces of ideas on vocational art, liberal education, freedom and examinations, has often enough been compelled to struggle on from day to day; only comparatively recently has the idea of sequences of work begun to take shape; but the total picture has seldom been more than a somewhat vague concept of creative expression as a 'natural' thing.

We must note that current ideas on the role of the teacher assign to him a more active part than he has hitherto played – and not only in art education. Jerome Bruner (1960) disagrees with the Deweyan view of the growth of understanding simply as a process of unfolding; he sees learning – and teaching – as also responsible for cognitive ability. His argument (grossly oversimplified) is that the culture into which a child is born provides him with tools for thinking – modes of organizing experience; some parts of our culture are rich in tools, others not. The ability of the individual to think depends upon the tools available to him. This is where it would appear that the teacher has a part to play; the art teacher as well as others. In other words, we must see that art in school is one element, perhaps neither more nor less important than any other, providing a mode of thinking and of organizing experience.

52

Marching under the same banner as Dewey were a number of writers and teachers in the field of art education in the last years of the nineteenth century and the early years of the twentieth. Of these, one of the most important was Ebenezer Cooke, whom we have already met as a follower of Ruskin. He began in the eighteen-eighties a period of investigation and writing in the teaching of art; in one article, written in 1885, he says

> The choice is between accuracy and interest, technical skill and child-nature. Agreed that truth must be had, but relative. The moral of the whole thing is rather – how to get it. . . . The child's attention is aroused and sustained by interest. The teacher who includes child-nature in his subject – its progressive capacity, its extending interests as they develop – will try and get this and all natural forces on his side. . . . The nature of the child can no more be altered by us. We must study, sympathize and conquer by obeying it.

Cooke knew James Sully, the psychologist, who attempted to place ideas about art activity on a psychological basis – tending to emphasize beauty and 'placing the child in an aesthetic atmosphere and companionship with nature'. At about the same time T. R. Ablett, who had been appointed Inspector of Drawing to the London School Board, founded the Royal Drawing Society, whose examinations were intended to encourage the spread of his own ideas on teaching drawing; he saw that drawing could be an educational process whose scope went beyond what others believed, though he lacked the theoretical basis to give support to his views, which he described himself as 'Drawing as a means of Education'. Others too were continuing Cooke's serious investigation into what happens when children practise art. One can see that the long battle against the Science and Art Department was bearing fruit, that progressive thought in art education had turned towards the idea of child-centred education well before the turn of the century; indeed, by the time that Franz Cizek was starting his art class in Vienna: his intention being much the same as theirs: 'to let the children grow, develop and mature.'

Many educators from this country visited Cizek, and exhibitions of the work of children in his classes were held in London between 1900 and 1910. His reputation here has been immense and is still considerable, yet it seems not altogether to be based on a true knowledge of his work. Partly this is no doubt due to the make-up of Viola's book (1942); the minutiae of the early part tend to make one omit the solid material of the descriptions of Cizek with his classes at the end. These still make excellent reading; what is often forgotten is that Cizek only admitted to his classes children with marked creative ability. The result was that, as Tomlinson has pointed out (1943) 'those who were not so gifted soon felt their shortcomings and absented themselves after a short stay'.

It was left, therefore, to Marion Richardson in this country to proclaim that *all* children had creative abilities. The importance of this idea in the development of art education in this country cannot be over-estimated. Her working-out of it at Dudley High School, where she developed brilliant methods to put her ideas into practice, was recognized in various ways (some of the work of her girls was exhibited in London in 1917), as was her passionate belief in the work she was doing and in the ability of all children to participate. When later she went to London and could influence a wider field, she was able to communicate her faith and her ideas to other teachers, and her methods (or what were thought to be her methods, for her famous 'descriptions' were travestied by others who did not really understand) spread during the thirties all over the country. 'How was it', she asks in her book (Richardson, 1948), 'that the work went forward? The times were ripe, the teachers' minds were ready, chiefly because of the growing respect for the individuality of the child. In art this respect is a necessity, for unless a child is expressing his own vision he is expressing nothing at all.' Certainly there was immense enthusiasm among teachers for the New Art, though sometimes it was so uncontrolled that as early as 1935 the Eccotts (*Teaching Creative Art in Schools*) were writing:

Some people think that self-expression means just letting

the children do what they like. It suggests sawing up the furniture and scribbling on the walls. From the teacher's point of view it is not so much allowing the children to do what they like, as seeing that they like what they do.

Then in 1943 came Sir Herbert Read's *Education through Art*, in which he brought together for the first time a mass of artistic and psychological material to make a case for art as a total means of education. This notion has not been taken so seriously as perhaps it deserves (though the Society for Education through Art has adopted the phrase into its title); nor has his complex typology of children as artists been found generally to be meaningful. Nevertheless the wisdom and humanity of the book and of his other writings on art in education won for Sir Herbert affection and esteem from art educators all over the world.

Marion Richardson's book did not appear until 1948. Since then – with some notable exceptions (Robertson's, 1963, for example) – the greater part of our written material on art education has come from the U.S. and has continued the emphasis on the growth and development of the child which Cizek had written of half a century before. Only within the last two years or so have certain art educators begun to argue that a truer balance must be sought between concern for the integrity of children and concern for the integrity of art. (Manzella: *Educationists & the Evisceration of the Visual Arts*. A provocative criticism of art education as the author sees it. Eisner: 'The Challenge to Art Education'. *Art Education*, Vol. 20, No. 2, Feb. 1967 suggests different curricula, not necessarily mutually exclusive, but with different aims. Barkan: 'The Challenge & Adventure of Change'. *Art Education*, Special No., Sept. 1967. On the need to recreate education in art into a major force in aesthetic education.)

GOOD DESIGN AND THE EDUCATION OF TASTE

One demand, above all others, has been made continuously of art educators since the first days of the Government School of Design: that they should concern themselves with design. In-

deed, art educators have made the demand of themselves; one such wrote recently :

> If any indictment of contemporary art education is necessary one need only look at the aesthetic slums which are our cities, crammed with a neurotic proliferation of products. The formlessness of aesthetic vacuity can only be matched by the pretentious artiness and functional insufficiency. It is very apparent that Art and Education have much to answer for !
> (Tom Hudson in *Design Education, i*, Hornsey College of Art).

This is presumably an attempt to indict both designer and public. The demand being made of the art educator is that he should have educated the former to design more efficiently, the latter to discriminate more wisely. One can see that the matter is far too complex to be fairly put in such a wordy diatribe; but the substance of the complaint embodies the old problem : in what way is design the business of the art educator? and the further question : if society requires art education to concern itself with design, has it failed to do so because of inadequacy, or because it has not tackled the job?

We must first look back in time and see how these questions have posed themselves and what sorts of answers have been offered in the past.

The Ministry of Education Pamphlet No. 6, *Art Education* (1944) seems to make the assumption that one of the aims of the art teacher is to teach discrimination :

> Art has ceased to be simply a frill, and holds its place as an essential element, in some form or other, in a sound general education. The art and craft subjects provide an outlet for creative ability, stimulate the imagination, develop discrimination in design and the sense of craftsmanship . . . [Later the point is made that] the actual making of things by the pupils leads to an appreciation of good standards of design and craftsmanship. [The report goes on] It is probable, however, that special methods will have to be adopted in order to help the pupil to relate the experiences gained in his art and craft lessons to his environment.

This passage is interesting for more than one reason. The argument advanced, that the practice of art teaches discrimination, is the classic one advanced by art teachers to indicate that what they are doing must have an influence on design (though perhaps the crucial point here is: what kind of art?). The rider added at the end shows that the writer too had his doubts about how far the practice of art by itself might aid in the understanding of design. In spite of the good sense of this report, there is not much evidence of its suggestions in the matter being taken very seriously by art teachers.

The pamphlet seems clearly to have been written in a favourable climate of opinion – favourable that is to the idea that design is the business of the art teacher. Indeed, during the Second World War there was an astonishing recrudescence of interest in the man-made environment; the Town and Country Planning Act is but one example of the idealistic attitude of those days. Yet the stage had been set earlier. In 1937 Anthony Bertram gave a series of broadcast talks on Design, published in book-form by Penguin the following year. In his foreword Lord Sempill, then President of the Design and Industries Association, wrote: 'The battle will not be won until the desire for beauty in everyday life and an understanding of the principles of design are part and parcel of our general education.' In those last years of the thirties there was a great interest in design; Osbert Lancaster's witty and pointedly critical works *Pillar to Post* and *Homes Sweet Homes* appeared in 1938 and 1939; Margaret Bulley was writing her books inviting the reader to compare art and no art, good design and bad design; and the D.I.A. was publishing instructional sheets on chairs and so on to stimulate an interest in design in the schools.

Yet during the thirties the Royal College of Art under Rothenstein was determinedly biased in favour of fine art; even the appointment of Jowett from the Central School with a mandate for reorientation made little change. (Not until Sir Robin Darwin was appointed in 1950 was there a thorough purge and a fresh start made.) Throughout the thirties there were complaints from industry and commerce that the schools of art were failing to produce designers of much practical use.

57

Although the R.C.A./Goldsmiths ATD course made a real effort to induce its students to see that art must exist in the context of contemporary society and technology, few of them seem to have made more than a perfunctory attempt at dealing with design in the schools. A Penguin series called *The Things We See*, published in 1947, did not sell, and could still be seen on the bookstalls years later. Finally, in the middle sixties it was possible for the Art-Teacher Training Centre of Hornsey College of Art to present itself as a pioneer in Design Education.

So, here is the situation set out: for at least a hundred and thirty years society has been demanding, first, of schools of art, that they train designers; which they seem not to have shown much interest or efficiency in doing until the last few years, and, second, of schools of general education, that they concern themselves with education for discrimination; which they have shown a notable unwillingness to do overtly, and have seldom done very seriously or sustainedly.

In attempting to analyse this situation, the first question which one wants to ask is, of course, how serious are the demands being made? In one respect, at least – that of design for industry – one cannot think that the demand is very serious; for until recently the schools of art were lamentably equipped to play any part at all in this field, and were – perhaps still are – hampered by the hangover of the long-outmoded Victorian idea of Applied Art. It seems so very obvious that design in industry must be the work of a team, and that the members of the team cannot be adequately trained in isolation; yet until comparatively recently little had been done in this direction.

Nor does the demand on art teachers in schools of general education seem very sustained. This may, of course, be partly due to the fact that in secondary schools the handicraft teacher is especially sensitive in all matters relating to design; possibly art teachers tend to feel that this is someone else's preserve. It is a tragic fact that in art and handicraft we have elements which should be close together, but which for historical and temperamental reasons have split apart. If both sides took seriously education in design, this could be a unifying factor.

There is, however, another reason which may be central to

the art teacher's resistance to the teaching of design: this is the pull towards fine art, noticed by Quentin Bell of students of the first Schools of Design, and evidently felt at all levels of art education since then. This would seem to relate to the artist's idea of himself primarily as artist and secondly as teacher: if the artist as artist can be himself (Reg Butler: 'when I am making art I am most myself') then as teacher his duty is to help his pupils to be themselves – e.g., free them from restraints; obviously he feels most free when he is acting as a 'fine artist', and he is therefore happiest when dealing with fine art with his pupils. Other matters such as design involve compromise – possibly compromise with business, suspect to the idealist artist. The many exceptions – designers honourably committed to designing or teaching – do not invalidate the general picture of a drift towards fine art throughout art education.

If this preoccupation with art can be traced back through Ruskin, perhaps there is another pertinent development, to observe which we must look back to William Morris. He saw clearly that the artists of his time were living in an ivory tower, far out of touch with ordinary people and everyday life. 'I do not believe,' he writes, 'in the possibility of keeping art vigorously alive by the action, however energetic, of a few groups of specially gifted men and their small circle of admirers, amidst a general public incapable of understanding and enjoying their work' (Letter to the *Daily Chronicle*, November 1893). He saw that the division was a social one: '. . . the question of popular art,' he says, '[is] a social question. . . . What business have we with art at all unless all can share it?'

Thus wrote Morris, foreseeing the democratic society of our own time. But Morris's fatal weakness was that he had two voices – that of his speeches, and that of his work. In the one he demanded art for all; by the other he made art for all impossible. For his idea of art sprang from his belief in the joy of the maker: not inspiration, but craftsmanship, was his god. Hence machine-production was anathema to him; the way for beautiful objects to be made was by hand. They must therefore be

scarce, and for the few only – 'for the swinish luxury of the rich', as he himself once said.

Morris's followers, who formed the Arts and Crafts Movement, preached the same gospel, and through them his influence was widely disseminated. A host of craftsmen and craftswomen appeared, dedicated to a belief in handcraft; many of them moved into the schools, where they established a tradition of honest craftsmanship which is happily not entirely gone even now. The obscure belief that there is something mystically fine about the handmade object is a legacy of their teaching. Many teachers who have never 'taken the wool from the sheep's back' subscribe to the idea of honest craftsmanship for joy; and have acquired thereby a distaste for machine-produced goods equal to Morris's own. This attitude has continuously coloured the approach of many teachers to the matter of education in the principles of design.

There is another aspect of crafts in education. The history of handcraft and handicraft in the schools has been told elsewhere (Sutton, 1967); here we must note that these activities found support on practical grounds (that handicraft would excuse boys from some apprenticeship time); on psychological grounds ('healthy mind-growth is difficult and exceptional without manual and motor-activity . . . we feel we cannot be wrong in recommending "more doing" . . .' Percy Nunn, 1912); and on educational grounds (the Consultative Committee on Practical Work in Secondary Schools, 1913, held a 'conviction of the great importance of Handiwork for the purposes of Secondary Education . . . as a necessary constituent of a liberal education.') The result of these beliefs was a proliferation of handwork activities of all kinds in the schools – from raffia-work to barbola – sounding rather like middle-class dispensations to the deserving poor. Attempts were made to improve the quality of things made; the criterion proposed was that they should be really useful; it was recommended that 'everything should lead up to a genuine craft' – meaning of course a useful craft – until at last the point is made overtly: 'Practical illustration of . . . principles of design . . . will illumine the pupils' minds . . .' (L.C.C. Memorandum on Hand-

craft in Senior Girls' Schools 1933). Nevertheless, the art teacher (including here the teacher of crafts other than wood-work and metalwork) has obstinately stuck to his point of view; he has assumed that the practical work done by his pupils carried within its doing the apprehension of the principles of design, and there he has rested. The teacher of handicraft has come to recognize that design must be his business, but he too has experienced immense difficulties in dealing with it, stem-ming partly from his own education, partly from the internal technical problems of learning design practically in wood and metal; his interest seems currently to be turning towards tech-nology and science.

The crucial point, of course, is the assumption that design is something that must be left to the artist and the art teacher. After the disasters inflicted on our environment during the last century and a half, it is surprising that the assumption can still be made. Design is a compound of artistic, social and techno-logical elements. At every stage in the process of designing, decisions have to be made involving comparative evaluation of these elements. It is surely useless to attempt to teach the artistic elements of design in isolation; undoubtedly the art teacher is right in refusing to do this. Only an approach which recognizes the compound nature of design is likely to be in any way realistic.

THE INFLUENCE OF ART

Marion Richardson has recorded for us her delight in the first Post-Impressionist Exhibition organized by Roger Fry in 1912. 'The gallery,' she wrote, 'was hung with pictures which in some strange way were familiar and yet new to me . . . a common denominator was evident between the children's in-finitely humble intimations of artistic experience, and the mighty statements of these great modern masters.' It was during her first summer holiday from teaching at Dudley that Miss Richardson saw this exhibition, and responded so naturally to the work she saw there. The experience coloured her imagina-tion to the end of her days and affected teachers' expectation of

what children's pictures should look like for more than a generation.

Throughout those years from 1912 to 1950, it seems to be the case that, as her influence spread, when teachers thought of children's art they thought of picture-making, and when they thought of picture-making it was a stereotype of Miss Richardson's children's work that they saw. Of course individual teachers responded to newer art-forms: Tomlinson (1943) writes that some teachers taught 'imitation cubism, imitation futurism, imitation purism, and many other "isms".' Others took ideas, forms, subjects, materials and techniques from the work of the professional artist. In particular the vitality and enterprise which teachers showed in appropriating new materials for expressive use during the forties and fifties spelled the displacement of the picture, which now survives vestigially in the examinations for the General Certificate in Education.

If we look back to the work of children in Professor Cizek's classes, we can clearly discern there elements both of Art Nouveau and midddle-European folk art. The evidence of Viola on just what influences Cizek himself may have exerted is fairly clear: certainly he told the children how to deal with outlines: 'You should not shade with your pen, but only draw an outline . . . each man you draw should be outlined'. He also controlled tightly the form of the work: 'we shall draw a line in the middle . . . [shows line]. It is supposed to be the floor where the horse stands. Then the horse will reach from the floor to the ceiling. . . . Below the middle line we shall draw something quite different. . . . A horse, and this horse is pulling a cart.' The report continues (Viola, 24 January 1936), but perhaps enough has been quoted to make it clear that the particular character of the work of Cizek's children sprang in great measure from his own instructions, advice and demands.

These two examples show highly creative teachers exerting a powerful influence over their pupils; almost certainly without being aware of the total effects of what they were doing; without being aware that they were operating pedagogically within the limits of their own artistic vision.

We ought perhaps to note at this point that for a great many

62

teachers of art, right up to the present day, the thing made has, so to speak, a prescribed form : it is expressive, and it has unity; no matter what materials have been used in its construction. This idea was conveyed to children, either directly or indirectly; so that, whatever the content or symbolism of their work it was 'art' in their minds and in that of the teacher.

The form of Cizek's children's work influenced the form of children's work here little if at all; while we have seen that the form of the work of the Dudley children had an immense effect – which inevitably still survives in the minds and work of older teachers. We have now, however, to consider a new set of influences which operated directly on the English art-educational scene. The artist-teachers who were responsible for the evolution of what has come to be known as Basic Design knew very well what they were doing. Their watchword was 'a New Art for a New Age', and they set out to be deliberately iconoclastic towards what had become established academic methods of teaching art, both in the schools and in the colleges of art. They began by concerning themselves with new ideas (new in an English context) for foundation-courses in colleges of art. Their debt to the *Bauhaus* was undisguised; they were greatly influenced by Klee and Kandinsky and Mondrian and *de Stijl* – indeed, their insistence on the use of the right-angle wherever possible in their exercises rapidly produced their first cliché – still, alas, with us.

The soundness of the original impulse (the founder of the movement was Victor Pasmore) and the academic barrenness of the schools of art are both attested by the rapidity and completeness with which the arguments – and many of the exercises – were adopted. That Basic Design has already – in the space of less than twenty years – become academic must not be allowed to become entirely a criticism of the founders. Maurice de Sausmarez, who became a spokesman for the movement, wrote that Basic Design should be

1 an attitude of mind, not a method :
2 primarily a form of inquiry, not a new art-form :
3 not an end in itself but a means of awareness, and a fostering of inquisitiveness (de Sausmarez, 1964).

The statement is impeccable; but its very reasonableness makes an ironic contrast with what actually happened. The founders of the movement – gifted teachers – devised a series of exercises so potent that they were taken over almost unchanged (and unchallenged) by teachers, thus spreading and strengthening the form of the work; which was in a particular idiom and conveyed an art-form. An inevitable problem comes to the front at this point: the difficulty students experienced in using the Basic Course as a basic course, unless they followed its forms and continued to work in an abstract way. The problem was obscured by the fact that most students wanted to work abstractly; the transition point simply disappeared; but there always were students unable to move on.

None the less, it does seem that as a result of the Basic Course movement a good deal of far more imaginative teaching has appeared in the schools of art; and one hopes that a new generation of teachers is in process of developing a more contemporary approach and is thinking seriously about the transition stage from foundation course to the succeeding period of self-development.

The protagonists of the Basic Course have made determined efforts to disseminate their ideas through the secondary schools. Here, on the whole, they have been unsuccessful, partly because of the difficulty of securing understanding of their principles, and partly because of the difficulty of relating basic course exercises with other work. On the other hand, as in the schools of art, they have woken teachers to the fact that the art teacher can – should – be active and not passive; and they have broken in upon the entrenched idea that children must make art. The ambiguous exercise, that can be looked at in two ways, is another weapon in the attack on the picture; a potent element for change.

We have seen how the major innovators in art education in this country operated within the context of their own understanding of art and its forms. What is true of them is true of all teachers of art. There is, however, inevitably a time lag, though perhaps this is shortening. When the young men and women whose work is seen to be in the forefront of the time go to

teach, the understanding within which they operate is con-
temporary. Moreover, whereas twenty years ago – and even
less – teachers were expected to develop creative work in
secondary schools using materials and techniques which they
would not use themselves (papier mâché), they have now re-
jected such activities in favour of activities which are their
own (print-making); these they can teach with a great deal
more conviction. Possibly another element disseminating ideas
about contemporary art more quickly has been the travelling
exhibition, which began during the last war to bring new work
into even the smallest provincial galleries. No doubt, too, the
retrospective and teaching exhibitions which have been a
feature of the Tate Gallery in the last few years have played
their part in communication between contemporary scholar-
ship in art and the teachers.

CHILDREN AND ART

We have seen how in the minds of educators the child has
emerged as a child, an organism with needs of his own, with his
own potentialities to be realized; an individual to be respected.

We have seen how art educators saw their role clearly : to
provide circumstances and a situation for growth, to set
children in this environment, and to stand aside – not to inter-
fere. Cizek said, 'I have liberated the child.' Yet he also said, 'To
let the children grow means to let them grow according to
their eternal innate laws. But in order to do that I must know
these laws. If there is a misunderstanding of "do what you like
to do", nonsense may result.'

As a result of his observation of children Cizek formulates a
number of stages – not necessarily clearly defined – through
which children pass in their development of understanding
through formulae – taking the circle, the triangle and the pro-
file as indicators. He was not of course the first to do this – since
the eighteen-eighties psychologists had been interested in the
phenomenon of children's formulae – but it was not until 1931,
when Helga Eng's book *The Psychology of Children's Drawings*
was published, that art educators had a really sound basis on

65

which to work. This splendidly detailed book remains a standard work. In 1947 the basis was amplified by the publication of Lowenfeld's *Creative and Mental Growth*, in which the stages of children's development in art are linked with their growth as individuals and with possible procedures by the teacher. The book is a mine of useful material for the art teacher, though its apparent precision (of dating stages of development, for instance) may be misleading.

Here we need only treat the matter in general terms. The theory is simply that the young child, attempting to understand and structure his experience, develops formulae to give shape to his ideas. Each formula (christened by Sully a 'schema') tends thereafter to be repeated until it is consolidated – generally becoming more simplified and formalized in the process. A new experience may modify the original formula, and the modification is then repeated; and so on. As the child grows, so gradually the schema ceases to be adequate to explore developing concepts, and the child's drawings show his increasing curiosity and need to particularize. Some children pass more rapidly through these stages than others. Lowenfeld says, 'the type of representation which a child achieves depends largely upon psychological, biological and environmental factors, and the stimulation the child has received.'

Evidently the art teacher, particularly of primary children but also of secondary, must know something of the stages of development and the general theory of the schema. But we must go farther than this; for the normal procedure of the art teacher – that of aiming directly at changing the thing being made – leads to difficulties, especially when it is coupled with an appeal to visual appearance. If the schema is a symbol for a child's concept at a particular point in time, what is the use of trying to make immediate changes in the symbol? It is the concept which must develop; this may be a longer or slower process, not depending only on the child's drawing ability, and to be attacked in many different ways. We see again how wildly inappropriate an ordinary art lesson may be, even for some children in secondary schools. Even the simple idea, common to Western culture, that the whole of the picture surface must

66

be representative ('the sky comes down to the horizon, doesn't it?') has to be learned; and even then has no claim to be the only right way of using the working surface. This has to be learned – but perhaps when it is questioned or discovered, rather than at a time when the child's interest is elsewhere. In art subject matter does not change, media do not change, relatively. It is the relationship of the individual with these things that changes. The wise art teacher will be at pains to familiarize himself with these developmental stages in order that he may deal truly with these changing relationships.

The suggestion is clear: that the teaching which is required at these early stages is not art-teaching at all in the common meaning of the words; and the art lesson as such is of little value.

It was Lowenfeld who drew our attention first to the way in which children, as they grow through the stages of symbol construction, gradually differentiate themselves into two classes – visuals and haptics. We have taken a first look at this theory in the second chapter; here we must expand current ideas on it. Dr. M. J. Rouse reported on the work of Prof. Witkin of N.Y. State University (*N.A.E.A. Journal*, Autumn 1965). He had made a series of studies in various aspects of individual differentiation, and formed the idea that there were two broadly different modes of perceiving, linked with various other personal characteristics. Dr. Rouse attempted to relate these two modes to visuals and haptics without success, though her tentative conclusions are no less interesting. She suggests that individuals performing at the extreme in either direction can be regarded as of equal maturity; whereas those uncommitted individuals exhibiting neither extreme characteristics might be thought of as less mature, in terms of expressive behaviour. It is suggested that possibly these indeterminate ones may be those most in need of help from their teachers.

It is also of interest that a substantial number of individuals appeared to be able to change their style from visual to haptic and vice versa – in defiance of Lowenfeld's findings. Dr. Rouse suggests that this indicates a degree of flexibility characteristic of extremely mature persons.

It is greatly to be hoped that Dr. Rouse continues her investigations, since there is more that we would like to know; but what we have gives us a new look on our earlier knowledge of visuals and haptics.

Nothing that has been written anywhere makes any qualitative distinction between the two; nor does Dr. Rouse. It is, however, interesting to note that the 'good drawer' in a class in the children's eyes is most likely to be a visual; while students and teachers are likely to be more interested in the work of children showing haptic tendencies. We must repeat, too, that the constant appeal by teachers at almost all stages to the look of things in nature and in the environment tends to act as a slow process of conditioning which, unless tempered with very wise teaching, puts the haptic at a disadvantage. Dr. Rouse's study indicates that we would do well to take a serious look at our procedures, especially at secondary level, in terms of encouraging both groups; and that any pupil who appears to be in the indeterminate group should be given special consideration.

It should perhaps be emphasized that art teaching which is directed towards the development of individual response will automatically encourage both visuals and haptics; but will not automatically help the pupil who has not evolved a personal response, or who has lost confidence in his ability to do so. He needs further help. This would appear to be one of the areas where to attempt to teach art by practical means alone is not enough; for here, if anywhere, children need to explore – by practical and other means – the extraordinary variety of ways in which one can respond artistically to experience: all valid, all meaningful in their own terms.

It is not intended here to say that art teachers are at fault in referring to nature; after all, the environment – natural and man-made – is the raw material of art. We apprehend our environment through our senses; what would seem to be of the first importance should be to bring children to a growing realization of the mechanism of perception, to an understanding of the fact that the perceptions of different people may differ, and a grasp of the factors which cause differences. Differences in artistic vision can then be seen partly as differences in percep-

68

tion, and partly as differences controlled by other known factors. If then a pupil in a secondary school is asked to go and draw a tree, first, this will take place in an understood frame of reference, and second, the pupil will understand that he is being asked to make *his* drawing of the tree, not to attempt to make an ideal drawing of it. In other words, understanding of perception avoids the lack of communication between teacher and pupil which leads to the pupil supposing that he has to copy nature and realizing that he has failed, while the teacher praises qualities in the drawing which to the pupil are irrelevant.

We have seen that children bring to the classroom or art room their own innate characteristics, their own individual differences, themselves as people. They bring with them, too, the influence of parents and home, of their wider environment outside school, of the mass media. All these affect attitudes and interests shown in the school; in the permissive atmosphere of the art room these influences may play a serious and important part in what is said and done. The experience of children out-side school will after all form the main body of raw material on which they draw for subject matter; so that in a very real sense the children's outside world comes into the art room.

Some of these experiences will be 'first-hand' experiences – situations which children have actually seen or in which they have taken part; others will be 'second-hand' experiences – situations participated in vicariously by means of television or radio or through reading. In the case of young children the division is not a meaningful one: fact and fiction are all one. Picture a small boy walking down the street, shooting with an imaginary revolver at heads in windows – real and imagined. But as children grow older they are usually taught – often ruthlessly – to distinguish between what is real and what is fantasy. Even so, adolescents develop a private world, often retained into adulthood, and often alarmingly 'real'.

It is evident that in a certain sense all experience is 'first-hand', To a small child a street-fight seen in reality may appear to differ little from a street-fight seen on television; he dares intervene in neither, only wonder. It is equally clear that while the evidence that comes to his senses in the former case is monitored by no

69

one but himself, in the latter case someone else has selected the information, the emphasis.

Now, the young child making a drawing from either of these experiences is operating at a level of symbolizing comparatively unsophisticated; in either case he is compelled to select from a mass of material; he is not aware that some has been processed.

To the older child, however, a temptation presents itself : he may or may not be aware of the kind of processing that has gone on in preparing the television programme; but he may be sophisticated enough to respond to the results of processing. In this case, he may well accept the selection, the emphasis, without more ado; and attempt to reproduce it.

Herein lies a problem, to which art teachers respond in different ways; frequently agreeing, however, in disliking and fearing the mass media. Some teachers ban subjects chosen from such sources, most try to provide alternatives which depend upon 'first-hand' experience.

The first thing to be said here in comment on this problem, is that if we are talking about genuine creative expression or exploration in art, then we cannot distinguish between different kinds of raw material. Picasso said, in conversation with Christian Zervos (Ghiselin, 1952): 'The artist is the receptacle of emotions from no matter where : from the sky, from the earth, a piece of paper, a passing figure, a cobweb. This is why one must not discriminate between things. There is no rank among them. One must take one's good where one finds it. . . .' In the same conversation Picasso discusses plagiarism; saying that the only kind of plagiarism to worry about happens when the artist plagiarizes himself. I take it that he means that when he is, for example, using Velazquez's *Las Meninas* as a starting point, he is using the picture as a starting point, and not the picture as a reference to the real princesses.

This really makes the point : which is that if a pupil wishes to use images from the mass media as starting points for art experience there is no reason why he should not do so; only the teacher will no doubt wish to have it clear that there are certainly two possible alternatives : one, to do as Picasso has done

and use the image itself as a starting point for expression or exploration; two, an attempt to see back to 'reality' through the image and start again from there. Either way involves seeing the mass media as processing the raw material of experience, and therefore as needing interpreting. In this way, therefore, art is playing a part in educating children to understand and control their world, particularly in the all-important area of communications.

It is worth developing this point a stage further. For all of us, the world is no longer the narrow world of our own physical contacts; it includes the world through communications as well. The life of the mind, of the imagination, can embrace the whole world – and more – in space and time; it would be absurd in any way to seek to curb its expansion, to drag children back from their mental adventures to physical reality. It remains true, nevertheless, that we depend upon our 'real' experience to enable us to give meaning to our imagined experience, and therefore a greater richness in our realization and structuring of our actual experience will evidently lead to a greater richness of imagined experience. In its power of revealing unsuspected meanings in experience art must play its part in helping people to make a truer synthesis of all experiences.

We must conclude this section with a word on intelligence. It is sometimes stated that less intelligent children are 'better at' art; this is palpable nonsense; but neither is it true that there is any positive correlation between creativity and intelligence. (Getzels and Jackson, 1962). Of course in certain respects intelligent children may be more successful – for example where there are clearly defined matters to be learned or processes to be operated; but in the essential use of art to externalize certain areas of experience practically all children will at one time or another attain a high degree of success. Particularly for less-intelligent children, this attainment is valuable in itself in terms of self-esteem and confidence; and it may well be that the art teacher will wish to enable such children frequently to repeat their achievement. Nevertheless, the argument of this book for understanding as the goal of art education stands; only the

ways in which such understanding is approached must clearly differ according to the characteristics of different individuals or groups of children.

CHANGE IN EDUCATION

As an appendix to this chapter we must remind ourselves that education itself is constantly changing. Education as we know it today is after all a young phenomenon; it is only during the last hundred and fifty years that the idea of education for all has been accepted, and the history of education during that time is both the story of the expansion of education and the study of how educationists have faced the problems involved and through research and experiment have made the process progressively more efficient.

In the revolution in attitudes towards children which occurred at about the turn of this century, art education had a part to play; and from that time on for almost a half century, art education could claim to be progressive and in the forefront of educational development, with its respect for the child and his work, its efforts to stimulate individual development, and the scope it gave for creative activity. But the focus of interest and need has shifted elsewhere: society has demanded more of science, mathematics, languages; and the imagination of educationists has moved to the improvement of teaching processes in these areas.

At the same time the numbers of children in schools is expanding, while numbers of teachers do not increase correspondingly. The response to this situation, at first in the U.S., and increasingly here, is a revolution in teaching-methods – associated first with areas of need, but not necessarily limited to those areas. Language-laboratories, teaching-machines, closed-circuit television – these are bringing programmed instruction to increasingly large numbers of children; while team-teaching makes progressively better use of precious resources in teachers.

In this country we tend to pin our faith – for improvement in teaching – in reducing the size of classes (though we shall not

achieve a maximum class-size of thirty children until the nineteen-eighties); in fact there is evidence suggesting that a small pupil-teacher ratio is not necessarily related to better learning. It may well be that necessity will compel the acceptance of alternative ways of deploying teachers more effectively.

In these circumstances it is imperative that art teachers should be alert to new possibilities for the better teaching of their subject. We must ask ourselves with more purpose than hitherto what our goals are; and must be prepared to explore different ways of approaching those goals. We are wedded, by temperament and by long tradition, to certain ways of teaching; if with the passage of time our goals change or develop, then methods may need to change too. There may be areas in the total picture of art education – those primarily concerned with processes of evaluation, for example – where at this moment it is impossible to conceive any alternative to our present single teacher, single child relationship; there are certainly other areas – for instance, of technical instruction – where experiments with teaching-machines should be tried. It is finally greatly to be hoped that art teachers will help to explore the possibilities of team-teaching, since this is closely related to the more proper implementation of one of our principal aims.

4

Art education seen as a sequential whole

It is not unknown for teachers in any sector of education to claim that theirs is the important sector, and should be given more time, resources and effort; nor is it unusual for teachers in any sector to disregard – and sometimes to decry – what has gone before. Such attitudes are not very reasonable, even in particular cases; certainly they cannot be accepted as a basis for generally significant statements. The elements into which our educational system has crystallized have so separated from each other, have acquired such different procedures and traditions, that it cannot too often be reaffirmed that it is the same child who in turn passes through the infant school, the junior school, the secondary school, and so on into higher education. He himself will change and develop; his character and attitudes will be influenced by experience; he will not always require the same kinds of approach and treatment; but he will still be the same person, and what happens to him at any stage is likely profoundly to affect what he is and does later.

Even after recognition of this, when they think of the child and his art, many teachers are likely to think in stereotypes based on our division of education into working elements – the infant is thought to be spontaneous, the junior eager to learn, the secondary school child anxious to draw properly; and these stereotypes in turn condition what teachers expect children to do. The cut-off at eleven, when children leave the security of the class-teacher and face numbers of subject-teachers, exacerbates the total situation by giving undue empha-

74

sis to this point, and, in art, by suggesting that, whatever may have happened before, from now on children will certainly be expected to make art properly. At least the new schools for children aged nine to thirteen will help us to see across the latter barrier.

The failure to view art education as a whole is tragically evident if one talks to almost any young adult about his attitudes to and knowledge of art. Many will report that they were 'no good at art' or that they had to drop it at thirteen or so and feel hopelessly out of touch. Few have much knowledge of the work of great artists or of contemporary art, or have been encouraged to think about what art is or why it is thought to be important; few have thought at all seriously about art as a factor in ordinary life. Even more urgently for the art educator, few have much – if any – idea of the relevance of their few bits of practical work to their life as an adult. To few has it ever occurred that though they may not be able to paint a picture or carve a piece of sculpture, they may still, as adults, function as artists.

On the other hand, increasing numbers of young people are proceeding to schools of art or are taking art as a main course in colleges of education. There is a considerable interest on the part of young people in exhibitions – particularly of contemporary art – in our art galleries. Possibly – though we have no positive evidence of this – art education is having some influence on children in the sense that it is preserving or encouraging interest; while at the same time it is failing most conspicuously to enable many children to develop a coherent view of art or to think or talk adequately about it.

No doubt this is partly the result of compartmentation; perhaps at no level have the requirements of children of that age been properly met. Art teachers at every stage have – not unnaturally – thought of themselves as teachers of art, concerned continuously with one particular task: the development and preservation of children's expressive powers. Foundations have been inadequately laid, sequential development not understood; and the unwillingness of the art teacher to teach has meant that virtually at every stage children have been doing the same

things. We must now look at art as an element in education throughout primary and secondary schools and beyond, and attempt to discern what continuity of development might mean, in terms of the changing needs of children in learning and expression.

ART IN SCHOOLS OF GENERAL EDUCATION

The spontaneous creative activities of the very young child, which are both work and play, are directed intuitively towards the exploration of his world and the understanding and development of his relationships within it. He draws or dances or builds with blocks or plays with sand and water, both before and after reaching school age. For him these activities are not yet differentiated; he does not think of one as art, another as dance, another as mathematics. The skills he needs he learns himself through doing, and in his drawing he assimilates experience by symbolizing it and repeating the symbol until it is modified by a new experience.

The role of the teacher in this early stage is surely a very simple but difficult one: he has, without interference, without imposition, to encourage children to be involved in what they are doing, to feel its importance to them. What children are doing is important; is certainly not mere occupation; and has to be understood and 'entered into' by the teacher, if it is to continue to be living and meaningful for the child.

At this time as later the teacher has to provide materials for children to use. Lowenfeld (1964) makes the important point that even for children of this age materials should be 'true art materials', that is, not materials made especially for infants, but materials which the children will continue to encounter. But he goes on to talk about providing hoghair brushes, mixed powder-colour and large sheets of paper as the best materials 'for developing great freedom'. Certainly he adds a number of other materials for working on different scales, but it is difficult any longer to support the emphasis on working freely and on a large scale; this may be appropriate for some children, but there is no reason and no excuse for making children work on

76

one scale rather than another.

At this stage the teacher has no mandate to teach the children art, and efforts to do so which do not enable each child to develop his own symbolism represent not merely a complete inability to grasp the true motivation and nature of children's art, but also a blow struck at the very heart of their sound growth – their confidence in their own ability to structure their own world in a way meaningful to themselves.

The next stage is surely one in which children are coming to terms with the concept of knowledge and with the fact that human beings use various ways of thinking as tools to organize what is known and to add to it. Only gradually will art differentiate itself out as an understood mode of organizing experience, although of course children will have been using it in this way since they began to draw.

Evidently this stage grows naturally from the preceding stage and interlocks with it. Certainly in these early stages there would be no art lessons as such – the kind of creative activity exemplified in the arts must be able to be used freely by children in their exploration of phenomena in their environment – to begin with; possibly 'incidents' which might or might not be practical working experiences, but might be an excursion, the arrival of a new picture, a drawing by the teacher, might offer the first beginnings of talk about art. Evidence of differentiation would naturally arise from the free choices of children among the different forms of expression or exploration open to them; for even if there were no specific art lesson, art would be made, and poetry, and songs sung; only we can visualize how gradually the interest of teacher and children alike shifts from what is done to how. Not a displacement, but a shift of focus, is what might happen; talk in the classroom would not only be about what children do in terms of content explored meaningfully but artlessly, but also about how they do it – the artistic means related to the purpose. Then perhaps a child might say, 'That's a good idea – let's all do it', and the first proper art lesson might take place. It might be a printing lesson, because one of the children had made a wall in a picture by printing it with a bit of india-rubber. So all or most of the group might experiment with

printing from objects found in the room – one may imagine the excitement, the group-feeling.

Observe, not an art lesson which begins and ends and that is that. Our imaginary art lesson grows naturally out of children's needs, and one can see how in the beginning an occasional period of this kind might spark off the interest of individual children, so that, for instance, some went on printing and developed different ways of making patterns, others went on printing and became involved in developing skill in the process, others adopted the idea of combining printing and painting, others again went outside the immediate domain of art and followed up other interests. We can see the organic nature of such developments. We must observe, however, that the work done during a lesson of this kind may or may not fit tidily into the category of what we have come to think of as children's art. The work will certainly be done with the exploration of art in mind; but the teacher will not pin up the best bits of art on the walls, since the over-all objective is understanding and not attainment. Only gradually, as the result of growth in understanding by the children of what they are actually doing, will they classify some of their activity and products as art; and even then, one hopes, these pieces of work will not be separated from other studies, but will continue to be attacks on problems approached differently elsewhere.

It is obviously not possible to be very precise in relating these stages to age – nor is it desirable; it looks, however, as though the initial period might be thought of as lasting roughly until nine, and as though part one of the second stage – the part we have been discussing – might continue from nine to thirteen or so.

After about thirteen, pupils might be thought of as in part two of stage two; still in transition, but likely now to be reasonably conversant with the idea of art as a mode of thought; needing, however, considerable experience in initiating artistic problems, elucidating and working them out. Perhaps this statement isolates art too much; this is not intended. At least the arts – music, literature, drama – should not be separated from each other, in any capacity : what stimulates one person to paint

may provoke another into writing a poem or a piece of music. This ought to indicate a continuing creativity in the arts, and the exploration of common ground by departments. One must also go farther than this and support any proposals which bring the art department closer to departments other than those concerned with the arts. Such contacts would certainly lead on to discussions on the nature of art, on art as a historical and social phenomenon. Pupils would begin to see the way in which their own development in art had taken place; the idea of art would exist for them in a context both of their personal experience and of their knowledge derived from other studies.

We must now look at this situation from the other end; what might reasonably be the goals at which the schools should aim in art for school-leavers at ages fifteen and sixteen, and at age eighteen.

It would appear to be axiomatic that young people leaving school at the earlier age should have followed courses in art of an open-ended nature, which would enable them to develop as people not merely through the accretion of experience, but also through its assimilation. It is useless to convey children through a series of practical experiences in art and stop there. After they have left school, for them art remains a limited experience either of trying still to be a child, or of trying (without at all fully knowing what they were doing) to be an artist. It is suggested that we consider that our model of a continuous process of art education might lead to the satisfaction of four requirements:

1 Each pupil's practical experience should have been such (in breadth and depth) that he has had the opportunity to gain some real insight into the motives and procedures of the artist.
2 Each pupil's practical experience should have been so illuminated by discussion and exposition that he has begun to have some insight into the arts as a human phenomenon, as a social manifestation, as a medium of learning, and as a means of communication.
3 Each pupil should have begun to see the contemporary

79

situation in art in a historical context.

4 Each pupil should begin to see the arts in relation to himself in his future – not limited to the activities of his past, but as extensions of himself into his environment and his influences on that environment.

These requirements do not relate to the pupil's achievements or skills, although they presuppose that he has broadly carried out certain activities; they rather indicate certain kinds of understanding and certain attitudes which might provide a starting point for growth in the arts, and not merely an end-point to a course.

The great defect of the General Certificate of Education course in art is that it is backward-looking; not only in the sense that it merely terminates a course, but also in the sense that it thinks of that course as a first part of a classical training in art-making. It tests skills. To do this it sets exercises which – since pupils must pass examinations – become the common stuff of the art course during at least the last year before the examination. Object-drawing, plant-drawing, figure-drawing; there they all are – the pupils are so clearly learning to draw, and, the examination implies, to one end: composition. It is the last straw when this is called illustration, and has a literary basis. Any concessions the examining boards have made to changing ideas have been in the area of craft and design; but the central features have been unchanged for the duration of life of the G.C.E. and longer; for they were taken over practically unchanged from the old School Certificate.

Clearly a course of the kind being discussed here, with the kind of objectives stated or implicit in the four requirements given earlier, is quite incompatible with the G.C.E. examination as it is at present constituted. The examination for the Certificate of Secondary Education has the advantages over the G.C.E. of being a new examination, and of being in closer touch with what is actually happening in the art departments of secondary schools; but it gives great emphasis to the candidate's exhibition of course-work and tends therefore (perhaps in spite of itself) to put pressure on the candidate to produce good

80

practical work during his course. In this sense it is a limiting factor; perhaps any examination would be this. Fortunately new techniques for 'looking at' the progress of children are being developed (reported in *ACE* January 1968), and there are signs elsewhere of interest in alternative forms of examination; possibly the heyday of the examination is already past.

In any case, we should leave this digression, and proceed with our hypothetical course by considering the two-year course for young people aged sixteen to eighteen. Because this course is related so closely to the passage on into further education it must, one feels, be thought of as in certain respects a transition course, bridging the gap between general and higher education.

It would seem that a student who had passed through the kind of course we have been discussing, and who was able to satisfy the criteria outlined on pp. 79-80, might well have developed specialist interests of various kinds. He might have become interested in practical work, or alternatively in the study of one of the theoretical aspects of art. He might wish to continue a general course, or he might wish to work in a limited aspect of art, studied theoretically or practically or both. The course should surely be related both to what he has done and to what he wishes to do.

There is a real problem here : it lies in the requirements made by further education upon this two-year course, and especially in the demands of the schools of art. They have been, quite rightly, contemptuous of G.C.E. Advanced level, because they have been concerned about 'standards'. It would seem that two different things are meant here : skill and style.

In the evolving course which we have been discussing, I have suggested that skills might develop according to need. This seems a perfectly sound principle, indicating the way in which skills first develop, and emphasizing that they must be living skills, understood and not merely mastered, capable of modification and not rigid, growing and not static. In current art teaching practice this is usually interpreted as meaning that skills should not be taught; and children are often to be found unable to break out of a dead-end situation because they are unable to 'discover' the simple step that would free them. It is

81

not easy to see what is the connexion between skill according to need and no teaching; the true implication would appear to be that if teaching of skills is to take place, it must do so at the right time – that is, the time indicated by need. Judicious teaching of skills is long overdue – that is, of course, skills relating to the kinds of expression and exploration that form practical art-work; something rather different from the craft-skills that are generally thought of when one speaks of skill.

The concept of skill would appear to embody two inter-related elements: first, understanding of one's materials, and second, control of one's materials. Current art teaching does not do nearly as much as it should in either way, and with honourable exceptions schools turn out children without control or understanding. (We should perhaps indicate in passing that one factor in the omission of skill from the art teacher's priorities is undoubtedly his wish not to interfere.) But if we could secure some greater continuity in art education, especially in the crucial second stage from nine to thirteen, it is easy to see how children might lay the foundations for a real understanding of materials: their origins, constitution, characteristics, possibilities: and might, in the years after thirteen, discover an immense interest in the skills involved in particular activities. It might well be that children of thirteen to fifteen would enjoy and profit from a period of concentration upon materials and learning to understand and control them. So seldom do children have the chance to concentrate upon one interest and follow it through that one would welcome the possibility of some weeks being spent upon an activity of this kind; the organizational problems involved are surely not insuperable.

It is easy to understand that schools of art might feel that students coming to them from the secondary schools are deficient in skills. We must now look at the opportunities of young people to develop a personal style.

First of all, why should it be felt to be necessary to develop a personal style? Will a style not develop itself?

There is no simple answer to these questions. Under current practice students at school do not have much chance of

developing a style; largely because of examinations, which cut into the last three years with pressures to be accurate and representational. Many young people pass through a stage of being extremely interested in the whole idea of representation; in the almost mystical fixing of the thing seen so that you have it for ever, just as it was. This phase has little to do with one's ability to draw, little in fact to do with one's ideas about art; and doubtless most students would pass through it normally, if it were not that the examinations exerted pressure (or art teachers thought that they exerted pressure, which is nearly the same thing) to make them feel that they must continue to draw naturalistically to pass the examination. This is as true of 'A' level as of 'O' level – the one is only the other writ larger.

Possibly students freed from the threat of examinations would stand a better chance of realizing a consistent and personal view of their world; and certainly one would hope that children who had grown up through such a consecutive course as we have been discussing would take it as a matter of course that this is what art is about.

At this point we can say a word in answer to the question 'why a personal style?' – not in any sense to give a categorical answer; but to hazard the suggestion that if one has reached the point of beginning to bring together content and form in a personal way, with integrity, perhaps this is evidence that one's practical work in art is bearing fruit, and that one's experience has been and is being meaningful. Or, putting it in reverse, perhaps this is the point at which art teachers should aim in their general courses, in practical work.

We are thinking for the moment of a world without examinations – or at least, without the G.C.E. The development of individual students from about the age of thirteen would proceed at their own pace, so one would hope. Those with particular interest or ability would undoubtedly move on towards maturity more quickly. This would be of far more value to all than the present process of setting up two artificial hurdles arbitrarily. Perhaps the C.S.E. gives us the hope that at last we have an easily modifiable examination which will respond with reasonable speed to developments in art education.

Reference must be made to the practical provisions made for sixth-form studies in art in secondary schools; because in effect, until recently, there were none. In custom-built comprehensives things may be better; but in the vast mass of grammar, technical and modern schools the sixth-former who is taking art finds a corner in the art room wherever he can. Occasionally this is in a store-room – where he will either be regularly interrupted or may possibly find a short period of isolation; but more often it will be at the back of the room while one of the lower or middle forms has an art lesson. Here, at the mercy of the criticism and values of younger children, disturbed by the lesson and inadequately advised by the teacher, and with seldom a long enough run really to get under the surface of his work, he struggles to achieve the right 'standard' for 'A' level. In view of such insensitive provision it is small wonder that 'A' level work in art has so little standing. Not until – as a matter of course – the sixth-former has an individual working-space, not necessarily isolated completely but capable of being isolated, where he can leave current work and pin up ancillary and related studies, will practical provision be adequate.

We shall come to the provision of working-spaces and facilities in secondary-school art rooms in the final chapter. Here, since we have been discussing the unity of art education through primary and secondary education, it is only necessary to make the point that while art in schools is thought of simply as a practical activity, with perhaps a little art-history and a slide or two now and then, what is needed is simply studio and workshop provision. (It has taken long enough to reach this stage: many an unfortunate pottery teacher has a parquet floor in his workshop; and architects still fail to provide large enough sinks or adequate pinboard in new rooms.) Even so, it must not be forgotten that ideas of what is practical work are constantly changing: the whole idea of movement, for example, with its possibilities in the manipulation of light, in film-making, in machines and so on, will demand new arrangements of working-areas, black-outs, electric points and materials. If, in addition, we are to envisage the study of art as involving activities such as discussion, reading and writing, watching and

making slides and films, doing follow-up work on them, using teaching machines and closed-circuit television – then clearly our conception of what spaces are needed will require drastic revision. When in addition we think of our rapidly growing school population and our chronic shortage of teachers, then for more than one very good reason we must re-think our ideas on art-teaching methods to new conclusions.

SOME ASPECTS OF ART IN HIGHER EDUCATION

Colleges of education

The theme of this chapter – indeed, of the whole book – is that art education must be considered as an unity; in looking at the work of art departments in colleges of education we shall seldom be made to feel that this conception is being disregarded, for on the whole these departments, because of the nature of their problems, have tended to take some count of the previous experience of their students. Student intake covers a wide range of interest, aptitude and ability : at one end there are students who could have been successful at a school of art; at the other there are students who arrive at the art department in spite of themselves, because nowhere else in college can they find a home. Such a diversity can only be met by individual teaching, and this carries the clear implication of continuity. This gives to the work of many colleges a characteristic flavour, not to be mistaken nor decried; for though it may lack a certain air of professionalism it is genuine and personal. There are colleges, however, which appear to seek to operate rather like small schools of art, aiming at a professionalism of practical work which one feels can rapidly become meaningless in the college of education context. What would sometimes seem to happen is that lecturers, in their concern for the subject, take students out of their depth; assuming mistakenly that staff-supported work indicates the student's true position. One sees that lecturers working in a college of education are in a dilemma; the solution, however, is not a misleading attainment but a genuine understanding; and the link is a subtle one.

One problem which contributes to this dilemma is a very

simple one : there is not sufficient time available for lecturers to do what they wish. They believe implicitly in the value of art experience as an element in the growth and development of the whole personality of the student; and they are chronically short of time. One – sometimes two – days a week, minus teaching-practice, holidays, excursions and so on; in so short a time it is seldom possible to do more than provide a series of isolated experiences, when what is needed is the time to enjoy more continuous experience in greater depth.

One element which exacerbates this problem is the point of understanding at which students begin their course. We have in the first half of this chapter seen something of sixth-form work; since most main-course art students hold a G.C.E. at either 'O' or 'A' level, this is where most of them start : with certain practical skills, which because they have been acquired in something of a vacuum have little basis in real understanding. Since most art lecturers are devoted to the belief that the ideas and attitudes of their students must be respected, it is easy to see that their progress towards emancipation from the G.C.E. is likely to be extremely slow for most students.

There are of course teachers who can make even such brief experiences meaningful; whose lively contact with students taps responses at a deeper level and sets those responses in the mainstream of the student's growth.

Perhaps all these difficulties – the shortness of time, the weak-ness of take-off point, the teacher's inhibitions – would not matter much if the exercise were really worthwhile. But how far is it desirable in its present form ?

The colleges of education, as a matter of general policy, are deeply wedded to the belief that they have two tasks to per-form, and that these must be dealt with separately. One task is the development of the student as a person; the other his de-velopment as a teacher.

The mechanism for operating this principle is a simple one. The main courses, of which a student normally does one or two, are designed for his personal development; the professional courses, through which a student normally covers a proportion of the subjects he will teach, (and which are much shorter

86

than main courses) are concerned with the teaching of subjects. Education counts as a main course. By what may seem a natural development, while the subject departments deal with main courses, in many colleges the balance of control in the professional courses is shifting – or has shifted – away from the subject departments to the education department. Finally we may observe two other facts which concern relationships between elements: one, that students taking a main course in a department are not necessarily among the students taking a professional course in that subject; and two, that it is unlikely that a student teaching a subject as part of his practical teaching will receive much supervision from lecturers in that subject.

Professional courses are pitifully short. Perhaps two dozen sessions (in three years) of an hour or an hour and a half each can offer no more than a token attempt to provide a basis on which a student may build an adequate idea of art education. Lecturers in art departments do not of course entirely disregard teaching aspects when dealing with main courses; but this is unofficial and unrelated in any realistic way to what is being done in professional courses and on teaching practice. That the practice of art in junior schools is lacking in purpose, vitality, and direction is some indication that, in the field of art education at least, this system is failing in its purposes.

The separation of main and professional courses was presumably done to protect the main courses, and to enable students to continue their studies unlimited by the demands of the subject as material to be taught to children. It is not suggested here that main courses should be in any sense limited to the mere assimilation of teaching-material; what is suggested, however, is that under adequate safeguards the development of a much closer relationship between main course, professional course and practical teaching could produce nothing but good.

Let us consider for a moment what this might mean in practical terms. Suppose the lecturer to be considering work with clay. This might take the form of an extensive exploration – perhaps lasting two terms – not merely consisting of practical work, but also analytical procedures, considering such matters as technical knowledge, skills, content and form, and setting

the whole thing in a historical and contemporary context. Such a course would need to be concentrated and high-powered; its objective would be not simply the development of the student through practical work (though there would be practical work at the student's own level) but the development through his own experience, both actual and imaginary, of his understanding of man's approach to a single material. I have no doubt that many such courses do exist, and surely they provide an admirable foundation on which the individual student can if he wishes build a personal way of working with clay. But if one were not tied to current main or professional course dichotomy, it would be possible at all stages for short professional seminars to link students' own increasing knowledge and experience with their activities as teachers; and when students came to teach, supervision by those concerned with the course we have been discussing would further ensure that adequate bridges were established to enable students to use teaching experience when learning in their own work and its analysis. The present system seems to hint at the notion that the teacher knows best, and that teaching is a one-way process. In art, at all events, there can be no doubt that the creative process of devising appropriate activities for children, of seeing these as part of a total development, and of evaluating children's responses would feed back a great deal to the student's understanding of art as a human phenomenon.

Of course there are practical problems in such a proposal – some students may opt for a main-course subject which they will not teach, for instance – but such problems do not affect the principle.

Let us turn back briefly to the main course in art. As this has developed over the last fifteen or so years its emphasis on the goal of the student's development as a person has intensified, and has very largely crystallized down to an emphasis on the student's creative activity. Little or no work – aesthetics or art history, for example – has been done to help the student to build up an idea of art in the round. As in earlier stages of art education, it has been assumed that personal creative experience is enough; and often enough this experience has not

been very profound. But undoubtedly a course dealing with art education in the terms of the first part of this chapter would have to be a great deal broader. The student would need to be able to set his personal experience of making art into a conceptual framework, to see art as an element in the lives of us all, to see how it has come to be as it is; and this would surely be wholly good.

College art departments are now faced with the new set of problems relating to the new Bachelor of Education degree, for which already a number of departments up and down the country are preparing students. In practical terms the degree involves a four-year course with normally a Certificate in Education examination at the end of three. Whether we like it or not, there can be no doubt in anyone's mind that the new courses (although they seem likely to involve no more than a few students) will have an effect upon certificate courses – except in the cases of new Institutes of Education like Sussex, where the construction of both syllabuses was almost simultaneous.

Because of university demands it seems probable that the degree courses will include more theoretical study than the certificate courses. This study may range from written accounts and evaluations of experiences in art to more or less closely-structured courses in aesthetics and art history. Whatever form the theoretical work takes, it is difficult to see how students can reach any real depth of study unless they begin to lay foundations from their first year onwards. In so far as this means a more systematic approach to other ways of studying art than the practical, the influence of the B.Ed. may be good.

The danger lies in the risk of fragmentation. Certificate courses in art are practical courses built around students' interests and aptitudes. If departments are not able – or are unwilling – to forge close links between the new studies and the old; or if universities make too great specialist demands, in for example, art history or aesthetics, the whole thing will disintegrate, and the chance of real quality will be lost.

Art education needs a wider range of teachers than are at present available. Current diversification tends to be by skills:

one teacher is a painter, another a printer, a third a sculptor –
sub-divisions which become progressively less meaningful. All
are primarily concerned with teaching practical art, and gener-
ally prefer to teach their own specialization. Thus even prac-
tical work is liable to fragmentation. Most art teachers know
a little art history; few have more than a smattering of
philosophy and criticism. There ought to be room for teachers
who as well as teaching practical art could conduct talks and
discussions – in close relationship with practical work – to
develop a language for discourse about the arts; indeed, if team-
teaching in art is to be more than a name such teachers will
be essential.

Colleges of art

Of all the institutions concerned in the astonishing development
of art in education in the last fifty years, the schools of art
have had perhaps the most difficult time. Subject for far too
long to the Ministry of Education (art examinations – estab-
lished in 1853 – were the last examinations relinquished by the
Ministry); administered by their local authorities as if they were
schools of general education; often imprisoned on the top
floors of technical schools; the victims of successive purges
which decimated their number; with two new examination-
systems imposed on them in twenty years; and now – when
the best of them are at last achieving a little independence
(though how little has been shown by the Guildford and Horn-
sey imbroglios) – threatened without consultation with in-
corporation in polytechnics: in spite of all this many schools
have succeeded to a remarkable extent in bringing themselves
more up to date and creating something more truly approach-
ing a contemporary image of themselves. Indeed, in spite of
all, in the early summer of 1968 the schools looked to super-
ficial view to be more successful than for some years. The new
Diploma in Art and Design seemed to be fulfilling its promise
to be a better examination than the National Diploma in
Design before it, with greater range as well as (we all hoped)
greater depth; and really seemed likely to achieve in some

90

respects the status of a first degree. Yet even before the student revolt of May and June 1968 it was apparent that all was not well. We must look at the total picture a little more closely.

The National Diploma in Design examination had been instituted in 1944 to replace the former examinations in Painting, Sculpture, Pictorial Design and Industrial Design, which themselves were instituted in 1913. In the change, antique-drawing, perspective and the study of anatomy went, and plant-drawing was allowed in place of life-drawing. A four hundred year-old system had come to an end, and in effect nothing was put in its place (which presumably explains why basic design won such a bloodless victory in the schools of art in the fifties). Moreover, the retention of the examination by the Ministry was a guarantee that conservatism would have its way. *Plus ça change, plus c'est la même chose.* Nothing was very different; the apparatus of the schools worked as before.

In particular, teachers taught as before. It has become traditional in schools of art (and of course art students have carried the method into schools of general education) that the student works at whatever he is learning to do – painting or pottery or fabric-printing – and the teacher talks to him about his work. Such a method clearly requires using with great sensitivity; the teacher is in a position of power – the student is at his most vulnerable. It also offers great benefits, for the teacher can deal directly with the student's own problems, and can adjust what he has to say to the student's understanding as manifested in his work. In the hands of a good teacher the method works – though not without tensions; when the teacher cannot rise to its demands what all too often takes place in a process of in-doctrination. It is interesting to see in the schools of art a recoil from this method; teachers are making themselves available for consultation, rather than visiting the student arbit-rarily.

The problem has always been complicated by the ambivalent attitude of many teachers of art towards teaching. They are compelled by economic facts to teach, yet they have come through art school with their eyes set on a career as a professional artist, encouraged by their teachers to be single-

minded about this. If they have taken a teaching-course they have had time to re-orient themselves and perhaps to see that teaching is an art in which one receives as well as gives; but in fact few teachers in schools of art have taken teaching-courses. It is perhaps not surprising that the quality of teaching is uneven and conservative, or that attitudes towards teaching are mixed; it is however unreasonable for teaching-staff to infect students with their own distaste – and unrealistic, since many of them will automatically find their way into teaching in spite of all.

Of course, the schools have had their revolution in teaching: that originated by Victor Pasmore in the early nineteen-fifties, and usually known as basic design. In the early days it was often claimed as 'the only way' by its disciples; though neither then nor now could one endorse that claim, there is no doubt that it drew the attention of teachers in schools of art first, to the fact that there are other and more positive ways of teaching which focused on isolating problems for the student, and showing how those problems related to fundamentals, thus, so it was claimed, building up a 'grammar of form'.

Basic design swept the art schools of the country, and the idea of a 'foundation course' has spread to the colleges of education. Perhaps, however, it is already time for this idea to be questioned: it was not in any case purely an educational idea, and it may be doubted whether continuity between foundation courses and what follows is often adequate. It is possible that a core of studies, continuing over two or three years, embodying common-ground material and perhaps art history and theoretical studies, might be more meaningful and more efficient both in colleges of art and in colleges of education.

The introduction of Dip.A.D. brought its own problems, and we must now look at some of these.

When the Coldstream Committee, set up by the government of the day to make proposals for the replacement of N.D.D., designed in general terms the new Dip.A.D. structure, one of the objectives it seems to have had in mind was the 'broadening' of the course. The word can mean many things; the committee

interpreted it in part as meaning the introduction of what it called 'complementary studies'. The committee's statement about these, intended to be open, has proved in effect to be disastrously vague: 'any non-studio studies, in addition to the history of art, which may strengthen or give breadth to a student's training . . . genuinely complementary to the main object, the study of art.' One thinks one sees that something which *relates* to the study of art is intended; this is not stated, though 'complementary' implies it. Lacking more precise guidance, colleges have picked up the words 'non-studio studies' and have interpreted them to mean just about everything except mathematics. The result has been that students are expected to break off their studio-work for an hour or half a day or a day each week in order to do 'a bit of philosophy' or psychology or whatever – not always seen in a context, disconnected from art studies, and very generally considered unimportant and a distraction.

The matter is further complicated by the make-up of the student body, which, because of the expansion of schools of art and the raised standards of entry to Dip.A.D., now includes students with greatly varying degrees of interest in and knowledge of subjects other than art. There are obvious difficulties in so directing complementary studies that all degrees of interest are involved.

Pevsner has argued (*Journal of Liberal Studies*, Spring 1968) that complementary studies are necessary 'because it [complementary studies] occupies the intellect which does not get enough to bite on during studio hours and days'. This may be true of some students; it is certainly not true of others. The argument might be thought to be a strange one: that if the education of the artist does not fully engage his intellect, his attention must be diverted elsewhere. Perhaps the fault lies in the notion that the education of the artist lies wholly in the studio.

In the schools of art complementary studies and the history of art are normally considered together, since the Coldstream Committee insisted that the two together must occupy not less than fifteen per cent of the students' working time. It also ruled

93

that while students might present a long essay as evidence of study in complementary studies, they must take an examination in history of art. The intention was benevolent; what had happened before in the schools as history of art was often a mere genuflexion to the idea; what the Committee envisaged was something with more body and more scholarship. There were already heart-searchings in the colleges even before the students of Hornsey College of Art made it clear (Document 11, Association of Members of Hornsey College of Art, June 1968) that, in their view 'the end-examination forces Art-History to follow a rigid linear pattern. The function of Art-History should not be to provide examinable knowledge. It should inform and permeate studies in art and design.' It was certainly not only students who felt that the study of the history of art was assuming too great an importance; one can readily see that the demands of the subject itself, narrow, precise, and deep, would be intensified by a written examination, and its separation from other studies assured.

The whole problem is the greater because many colleges have set up separate departments of education to deal with complementary studies and history of art. These departments are staffed by teachers whose background is more likely to be university than college of art; when they were set up the possibility of dichotomy was evidently scarcely foreseen, and efforts to establish firm links between new and old departments were not strong enough. One is aware of a point of division in which both staff and students are involved; this is the point of weakness in the Coldstream Committee's attempt to broaden the course. To broaden has meant to divide, and this is calamitous.

This is not to argue that the impulse of the Committee was at fault; they saw the difference between education and training; but they still thought that the artist should be trained, and were therefore led to tack on 'education'. What was wanted – and is still urgently required – was a much more serious look at the possible careers for which the art student is being prepared; and an unbiased and independent study of the education of the artist.

94

Consider the foundation courses. They provide, one assumes, an opportunity for each student to study fundamentals; for this task a year is not too long – especially if what the student has done before is disregarded, as it usually is. But on top of this role the first year has to be diagnostic – on the basis of his interest and performance during this year his specialism for the next three years will be decided. Then as if these demands were not already impossibly heavy, during this same year the student has to compete for a place on a Diploma course; this involves preparing during the first two terms a folio of work for show. How can such a course – however well taught – be taken seriously?

If we go on to look at the Diploma courses themselves, it seems that the new grouping of individual disciplines into areas of study has not effected any great change in the parochial attitude of departments. It has always been difficult to move from one department to another; if the Hornsey Document 11 is to be accepted it is now difficult to move from one area to another. Dip.A.D. regulations give some guidance here: every student was intended to follow, not merely a vocational course, but one with some 'fine-art content'. In other words, each student, whatever his course, should have some contact with the fine art area. Yet it is often claimed that the attempt to 'raise the standard' of Dip.A.D. courses has resulted in more vocational courses, not less. This may be so; but certainly we are aware of over-specialized courses 'the linear structure of which' says Document 11, 'militates against versatility. . . .' One cannot help looking sympathetically on the Hornsey suggestion of 'network' courses which would cut across established boundaries.

In their concern for 'standards' the schools of art are undoubtedly expressing the proper concern of the institution of higher education for their subject. The desire to move the student on to specialist activity, to narrow his course down to essentials, can be explained in this way. Yet the events of 1968 prompt one to ask if the schools have come near enough to resolving the relationship between the subject and the student. There is often an ambiguity in staff-student contacts; in one

sense, over their work, teachers meet their students as individuals; yet through the history of the schools runs an odd vein of disregard for the student as a person (shown for example in the almost complete lack until recently of tutorial arrangements and the lamentable provision of common-room facilities in many colleges) which may well be related to current student unrest.

When the Coldstream Committee was designing the regulations for Dip.A.D. it deliberately rejected the idea of a separate diploma for teaching. In this it was undoubtedly right; such a diploma would have been considered no more than a poor relation. None the less, the narrowness of N.D.D. courses (Dip.A.D. students appear rather better equipped in this respect) meant that for years the Centres of Art Teacher Education had to struggle with the problem of broadening the experience of almost all students in art. The most intractable feature of this problem was normally the resistance of students; they considered themselves to be painters or sculptors or illustrators, and a great many of them were not emotionally prepared to look beyond this. Although their experiences on foundation courses have generally equipped Dip.A.D. students with rather wider knowledge, there is some evidence that the attitude is much the same. The viewpoint of the students of Hornsey towards the narrowness of their courses is therefore an interesting piece of evidence suggesting that it is very much the influence of the school of art which leads to narrowness.

What is meant by breadth in this context? It must first be emphasized that there is no wish to dilute or weaken the course in the school of art. An end-on system of educating teachers has its weaknesses; its great strength should surely be the fact that the student has been educated as an artist. But this has not always meant the same thing: during the Renaissance – and for a long time afterwards – it meant preparing an artist for a wide variety of jobs; the notion that he would only paint pictures would have been scouted as a nonsense. Well into this century the Royal College of Art was turning out students who could paint or carve or work in precious metals. Of course the notion that a painter is a painter is not

96

a new one – it has been suggested that it owes its origin to Michelangelo and the concept of genius – but however that may be, there is no justification for the argument that the only way to train an artist is to limit him to a single craft; or, conversely, for supposing that if his training equips him to paint and carve and make pottery that he is necessarily in some way less an artist.

Yet it would seem that there are still strong pressures against breadth in the schools of art. It is the more refreshing that the Hornsey students propose 'network' courses, and it is greatly to be hoped that the proposal will be given serious consideration. The implication would seem to be that students would be able to move freely over the whole field offered by the school, and would not be restrained within an arbitrary Dip.A.D. area of study plus fine art.

This would indeed be a revolution for the schools of art, involving as it would a really strong tutorial system outside departments, thorough staff-consultation and planning, and the throwing-open of studios and workshops to planned entry of all comers. It would, however involve a change of attitude so great as to appear extraordinarily difficult to achieve. Nevertheless, from the point of view of teaching, it might prepare the large numbers of students entering teaching much more adequately than at present; while still allowing a greater degree of specialization to the student whose future career demanded it.

We must next say a word about 'academic respectability'. The Coldstream Committee was briefed to set up a course and an examination system roughly equivalent to a first degree; once again the intention was wholly benevolent: in the world of education, so competitive both for subjects and students, art should also have a place in the sun. More precisely, the art student's course and qualifications should fit him to proceed to the highest levels of the educational structure alongside students of other disciplines. The parity is still desirable – but what price is to be paid? The answer given in 1968 was unequivocal: not the price that Dip.A.D. pays.

We are brought face to face with the necessity to break

97

down the student-group into smaller groups according to their intended careers. First come the artists – the painters and sculptors; do they need a qualification at all? Next come the designers, who, whether they need a qualification or not, must follow for at least part of their time a rigorous and limited course related to their specialization. Lastly there are the teachers – until now recruited from the ranks of the first two groups. Is there an argument for these three groups to share a common core of studies – something akin to the present foundation courses but spread over more than one year – around which each group will gather a different cluster of related or specialist studies? Or is an open organization of network courses possible – so that in effect each student has his own course? Whatever possibility develops, the welfare of all three groups must be considered; this means that the very real need in art education for research must be recognized, and entrance qualifications and final qualifications for those students concerned must at least be designed to be the equivalents of those of first degrees.

Finally, we must take one more look at the relationship between the secondary school and the college of art; and the first thing to be said is that normally there is little communication between art departments and colleges. The student entering college is starting again; he can forget what he did before. This attitude is surely misconceived; it depends on the notion that both the secondary school and the art school are doing the same thing – only one is supposed not to be doing it properly. But if the secondary school course were concerned, as is suggested in this book, with developing an understanding of art rather than with concentrating on personal achievement in art, such a course might form a more proper basis for what is to be done in the school of art. At the same time, there is no doubt that school of art courses and organization might be more happily orientated towards the student in helping him to achieve a more unified structure of experience.

Centres of art teacher education

A great many students teach when they leave colleges of art.

98

Apart from those who from the start determine to teach full-time, most of them look for part-time posts, and some find them. By far the greater number, however, teach full-time in secondary schools. Of those who consider teaching as a career, some five hundred and eighty each year spend their post-Dip.A.D. year in one of the thirteen (formerly sixteen : three closed 1967) Centres of Art Teacher Education.

Although there was provision for the training of art teachers before 1946, it was – with honourable exceptions – rudimentary. Descended from the old course leading to the award of the Art Master's Certificate, which was intended as training for potential Heads of schools of art, the courses of the thirties were still generally more concerned with what happened in schools of art than in schools of general education. Outstandingly distinct from the majority were Marion Richardson's course at the London Day Training College (later the Institute of Education), and the course for students from the Royal College of Art begun by Arthur Eccott at Goldsmiths' College in the late thirties; both deeply concerned with current ideas in art education for everyone. But not until the ex-service men returned to complete their education in 1945 and subsequent years did the majority of centres expand, build up staffs, acquire new premises (never built for the purpose and usually inadequate) and begin the long haul from amateurism to professionalism.

Because of their small size – none has normally had more than sixty students – and the comparative independence they were able to assert, they have been able to develop individual courses, have established their own clearing-house, and have promoted a conference intended for the discussion of professional matters.

Throughout the years since the war the centres have had to grapple with two major problems : one inherent in any end-on system of training, the other more peculiar to the area of art education.

The first problem is easily stated : during their years at schools of art, students acquire attitudes which the education course must attack. They become deeply involved in their own

99

development as artists; as intending teachers they must orient themselves to the development of others through art experience. They have to learn that art teaching is a creative activity, which for some of them may largely take the place of their own work; while others may need the refreshment given by continuing their own work at a high level. To whichever group they belong, they have to grow to realize that teaching is a two-way process, and that there is a feedback to the teacher's imagination; while their own creative activity leads to growth in their teaching.

The second problem (somewhat lessened since Dip.A.D.) springs from the fact that the courses leading to N.D.D. were almost entirely practical. Students did little writing and were unused to expressing ideas verbally; and thus entered upon an A.T.C. course quite unprepared for what as the years passed became a course increasingly concerned with complex ideas expressed in words.

The effect of these two problems was to compel centres to devise courses which engaged students' attention and interest and which organizationally treated the student as a mature individual. They became, almost in spite of themselves, among the more progressive institutions in art education.

But probably their most persistent problem has been that of bringing together practical and theoretical studies. One cannot conceive of a course concerned with the education of art teachers which does not include some practical art : for technical reasons, as preparation for practical teaching, as a workshop for the study of creative activity, and so on. Centres have devised a whole range of ways of integrating their courses; but this area of study seems to be the crucial point at which changing attitudes, changing methods and changing needs meet; there may always be flux here.

In spite of their unique position the centres have on the whole done nothing about the central problem of the content of art education (Hornsey with its emphasis on Design Education must be mentioned here); though it is fair to add that to give a real lead on content, centres need programmes of research; these are just beginning at the centres (Birmingham, Cardiff,

Leeds, London) where there is an advanced course in art education. (There is a Research Centre for Art Education at the Bath Academy of Art; we still await its full report on art in the sixth form.) The centres have naturally been concerned with method, and have encouraged their students to be enterprising in finding and using ways of making possible more individual work by children. They have been idealistic about art in general education; it is unfortunate that their interest has turned away from the preparation of teachers for schools of art, though this has in fact not been altogether of their own choosing. The schools of art have shown little interest in their centres of art teacher education, and have in the past seldom been prepared to co-operate realistically over such matters as practical classes or teaching practice. Their attitude is perhaps part of the widespread notion that if your students are interested, your teaching ability is unimportant; and that therefore the education of art teachers for schools of art is irrelevant. A further contributory factor may be the mystique with which many teachers in schools of art surround themselves and their craft; which would rapidly be swept away by a teaching course which concerned itself seriously with art school teaching.

In the area of teaching-method the centres have inclined towards conservatism, being still predominantly concerned with the individual pupil-teacher relationship which has for so long been the characteristic feature of art teaching. Certainly the centres have been deeply involved in the attempt to sharpen and inform this process; yet – if only because they wish to preserve it – they ought to be exploring all the possibilities of teaching-aids and extensions which are becoming available. Here in the centres if anywhere should be an ongoing programme of experiment and research in teaching art, in all institutions and at all levels.

Universities

Because of the piecemeal way in which our educational system has developed, the provisions and attitudes of universities for and towards art in education are extraordinarily varied and in

many respects inconsistent. Nor have the universities always been as enlightened as they might have been. This has over the years had serious repercussions, since in fact the influence of the universities is so great and is exerted over so wide a field. Through the art examination in G.C.E. the universities have had a stranglehold over the development of art in the secondary school. The Dip.A.D. was modelled on the first degree structure – not then recognized to be obsolescent. Through B.Ed. the universities are now – intentionally or not – exerting pressures on the colleges of education and through them on both primary and secondary school art; happily there are signs that in this latter case the influence of the universities is somewhat more beneficent.

There are universities where art is practised, universities where its history is studied, one university where an art course integrates theory and practice; in some universities aesthetics can be studied; some universities award diplomas, others degrees; some give their student-teachers in art postgraduate certificates in education, others give them art-teachers' certificates or diplomas; in some universities an art student can proceed to some higher qualifications as of right, in others he cannot; the Royal College of Art awards a degree.

The existence of this wilderness would not matter very much if it were not for art education's growing need for a firm and secure place in the hierarchy of further education. The matter is not simply one of 'academic respectability', as the Hornsey students have suggested. Art education has emerged as a field of study sufficiently demanding and rigorous to require investigation and research at many levels. It is a field in which the disciplines of art itself, as experience, aesthetics and art-history, psychology and sociology all have their place. To it students of these disciplines can and must contribute; yet centrally there must be the place occupied by the art educator; who may himself be an artist-teacher and will certainly be a teacher with a wide and deep practical experience in art. It is the art educator's place which is uncertain; his background may – almost certainly will – be education in a college of art (though students from colleges of education are pressing close), and at present

his possession of a Dip.A.D. is little more than a passport to limbo.

Already pressure is developing from students who have taken or are taking advanced diplomas in centres of art teacher education to proceed to further qualifications. It will not be long before students holding B.Ed. are coming forward for further study. Clearly a condition of imbalance within the field of art education would be created if these latter students held an advantage over Dip.A.D. students. It is therefore greatly to be desired that the universities should develop a more concerted and liberal policy with regard to art qualifications.

5
Art education in the future

It is necessary for us to look forward to the shape of art education in the seventies, and there are already a few signposts visible which, however crudely, offer pointers which suggest directions. One, concerned with the organization of education, points to further extension of comprehensive schools. A second points in the direction of cross-subject or topic-centred teaching at the secondary level. A third, which we noticed briefly at the end of the last chapter, points to the more efficient use of teachers through team-teaching and mechanical aids. A fourth seems to indicate a more positive role for the teacher in teaching. We must now consider these pointers in greater detail.

First, there can be no doubt that the introduction of the comprehensive school was a significant event in the development of art education. At one step the focus moved from the single art teacher isolated in his art room, to the art department with five, six, seven teachers, with a range of studios equipped for specialist activities, and with unimaginably greater resources than most single art teachers ever had. The change has scarcely borne fruit; what is done differs but little from what the old teacher did in his limited environment. Specialist craft-teaching is more professional, a greater variety of materials are used; perhaps the greatest gain has been that of confidence. The individual teacher, secure in the knowledge of the department behind him, has functioned at a high level of performance. Many possibilities, however, have not been realized : the greater

flexibility, the combined teaching, the realistic sequence, above all the establishment of goals which could set practical work in a context and give it a purpose. There are undoubtedly schools where new ideas are developing; but on the whole the comprehensive school still presents a problem – and an immense opportunity – to the art educator.

Second, we realize that we approach the matter of cross-subject teaching against a background of misunderstanding and disappointment. In the past too many attempts at collaboration have failed, generally because the role of art is supposed by others to be secondary, to be illustrative, or to give form to other people's ideas. This is entirely to miss the point that art has its own insights and offers its own structure of understanding. Even in working with teachers of drama, for example, the artist is usually only brought in at a late stage in production. Yet the artist, if he were called on from the first look at the script, could offer a valid and basic view of spatial and temporal organization based on his understanding of meaning in visual terms. But in order to play this primary role, art needs at each point of contact an advocate; and this in turn means that the art teacher must be convinced of the character and quality of the contribution his subject can bring. It must be emphasized that unless art can come out of the art rooms, unless it can play its true part in integrative projects, it may be doomed to a limited and dwindling role as therapy or recreation.

Third, the comprehensive school seems to offer in its art departments admirable situations for exploring more efficient ways of deploying teachers. Few departments are normally organized to take groups of children other than those corresponding roughly to forms or half-forms. Yet one can see that even comparatively slight changes in the content of the courses, together with a full and realistic use of audio-visual aids, might enable teachers to work with widely differing sizes of groups, with a consequent gain in efficiency, notably in the area of teaching or tutorial contacts between teachers and individual children. We must recognize that such a development has two important implications: one, that staff might need to be more versatile and perhaps to have different kinds of training, since

105

they would be approaching the teaching of art not simply through practical work, but through a whole spectrum of methods; and two, that the present physical organization of art departments would require drastic changes. The present inflexible series of studios and workshops, all fixed and all more or less the same size, would need to give way to a much more flexible arrangement of spaces, readily capable of rearrangement, and making possible the teaching of groups varying from a few to a hundred or so pupils.

Fourth, new ideas on the role of the teacher must affect the art teacher: art teachers have always been acutely aware of each child's potential as expressed in his work, have seen possibilities for development and have seen how these are limited from within as well as from without. But all too often the character and vitality of the work done by the child has satisfied the teacher, who has thus not always felt the need for further teaching. As we have seen, Jerome Bruner sees the teaching situation differently: he sees the child as born into a culture which provides him with the tools of thought – the arts, literature, scientific theory, and so on. The ability of the individual child to think is largely governed by the nature and richness of the tools he has at his command. Here, indeed, there is clearly a part for the teacher to play – and certainly the art teacher: for in art education as a whole it is most noticeable that while we try to ensure that children have experiences we seldom provide them with adequate means of analysing those experiences, or of relating them to each other, to abstract principles, or to other modes of thinking.

It is time that we looked at our problem from the other end. Let us forget for a moment what art education has been, how it began, the key points in its development, and think simply of children – people – and art.

Henry Miller, in one of his most stimulating passages (*The Wisdom of the Heart*, and reprinted in Ghiselin, 1952), writes

I believe that one has to pass beyond the sphere and influence of art. Art is only a means to life, to the life more abundant. It is not in itself the life more abundant. It merely points the

way, something which is overlooked not only by the public, but very often by the artist himself. In becoming an end it defeats itself . . . it is only a substitute, a symbol-language. . . .

In this passage Miller is developing the idea that man uses art as a means of exploring and organizing his environment and his experience; he goes on to propose that this is a stage only in man's development, and that a life 'beyond art' is possible – e.g. when life itself becomes art. This notion is certainly not generally acceptable; and indeed it is not easily possible to visualize a stage in man's development when he would not need to operate by means of his environment, when he would not be dependent on it for the raw material of life. The passage quoted is, however, interesting in this context because of its implication that art is for all of us a means of understanding as artists: that is, we all, at some time and with different degrees of intensity, are able – and need – to structure our environment artistically. With our present degree of understanding, all that most of us can do is of a fragmentary, disconnected, nature. It is clear that if we are to function as artists – in the widest sense – in the adult world, we need something more in preparation than the incoherent experiences which are the way art education presents itself to many children and young people. What we need is both a truer and deeper experience of art together with something more approaching a global grasp of art in the life of mankind. The theme of this book is concerned with the idea that an understanding of art in these terms could be the objective of everyone's art education. Such an idea involves Henry Miller's belief that the practice of art is not an end in itself, nor is the making of works of art its goal; it is part of the process by which man, working on his environment, builds his own view of himself and his universe. Since this is a 'life-giving' activity, many other values accrue to the individual, and these are often emphasized; they do not obscure the central element, which must now be looked at in more detail. It would seem that teaching for understanding in the arts might involve pushing outwards in at least six directions:

First must be placed creative experience in art; that is, the practice of art. Practice is revealing at different levels: it can readily, for example, expose problems and possibilities in a medium; at a rather deeper level it can aid understanding of structures and properties outside art; at a yet deeper level it affords insights into the nature of art; at even deeper levels come life implications and understandings through art. To be worth while, therefore, study must be in depth – a phrase often used but seldom clarified. It is usually taken to mean prolonged study in a particular craft; in our context we should emphasize the elements of initiation, sequence and development, without necessarily tying them to particular crafts, materials or techniques. The need is for the pupil to experience a total creative process in art, from the uncovering of a starting point through problem-formation, exploration and move towards solution, as part of a sequential programme spread over a period of time.

One other aspect of creative practical work must be recognized. Art is an anarchic activity; its internal evaluative processes are its own; it recognizes responsibility only to itself. In taking art as an educational means one is attempting to harness the whirlwind. The problem is of course to ensure that in practical work one is dealing with art, and is not in fact creating impossible conditions, in which work is done, but somehow the essential rogue element is missing. In advocating systematic study I do not wish to tidy the vitality out of art. I believe the two to be compatible; indeed, if we can accept the numerous descriptions of the creative process, without a preliminary period of systematic work, creative insight will not occur.

It must be understood that all subsequent points hinge on this first one of experience. Art teachers have always realized the pivotal nature of art experience, and have taught in relation to it. The difficulty – and it is a very real one – has always been in the teacher's use of the thing being made.

The second point, then, must be the pupil's growing understanding of art as one of a number of modes of organizing and internalizing experience. One sees at once that this goal of the teacher cannot be considered in separation from practical work;

108

but it does clearly imply a growing *conscious* understanding. In other words, the pupil must become self-conscious about art. There is nothing difficult or unnatural about this in terms of young people growing up: the difficulty lies in the unwillingness of the art teacher to analyse experience. It seems that here lies one fundamental area where school of art courses are not as yet laying the right kind of foundations for a teaching career.

Third, the pupil must begin to know something about the way in which art has developed, upon what factors of environment it depends for nourishment and flowering. This ought properly to be as much a history of developing ideas of and about art as a history of art production; and might be at least as much concerned with art and society. It is not suggested here that the study of the artist, his works, and the factors and influences that shaped those works, is not an important study. Such study might well form a part of art-historical work; but for pupils at secondary school who will not become professional artists something different is surely required. In our society there is a tragic dichotomy between the fine arts and the arts of use which often leads us to suppose that the fine arts are 'art' while the rest are 'applied' or 'everyday' art. The division – in the history of world art – is an arbitrary one. Our children should begin to grasp how it came about, and should know something about art as a whole; should begin to discover with us, for instance, that the professional artist and the art teacher alike are adopting a wider range of materials and techniques and processes and are extending the range of the 'expressive' arts. Is this a movement – quite unconscious – of despair at the exclusion of the artist from what are thought to be the important areas of current activity? Teacher and pupil alike need to carry inquiry and speculation about art and society right up to the present day.

Fourth, the pupil must begin to form conceptions of what the arts may mean in his own life. This surely means that what goes on in the art lesson must not always be too far removed from ordinary life. We must not be too purist about art; for if people are going to be creative in the arts after they have

left school we must recognize that the scope for such activity will not tidily correspond with art room studies. Many teachers already do much to bridge this particular gap; but what is certainly needed is the development of the conception of the ordinary man and woman, not as passive consumers, but as active and creative in response and in using. People themselves need convincing of this, which means that the pupil must learn, not merely to discriminate, but to be courageous in his discrimination. This in turn means retaining and strengthening his confidence in his judgement; and this undoubtedly implies a radical re-thinking of the whole business of appreciation. Too often the teaching of appreciation means teaching pupils to like the right things. Often it is assumed that a course of films or slides of 'good' art or a visit to the Design Centre or even the provision of a beautiful school environment will contribute materially towards developing discrimination; such procedures often merely convince pupils that they have no taste, since they do not like the things presented as 'good'.

The plain fact is that we do not always respond to the things we recognize as worth while, even when we are adult; which perhaps suggests that in demanding response to quality we often make no allowance for the individual to develop his own scale of values. To do this is a life-long process, a long and wandering voyage during which one explores – or ought to explore – many strange places. At any one time, while retaining the right to move on tomorrow, one ought to be convinced that what one has found is the real thing. Young people in secondary school ought in art to explore unusual tastes, and should feel able to discuss these without being made to feel that they are wrong, or – worse still – to feel that such tastes are oddities which they will outgrow. The important point to bear in mind must always be the understanding, the sensibility and the ability to defend in discussion which ought to lie behind the formation of likes and dislikes.

I do not think, either, that we should regard universal good taste as the to-be-desired end of our teaching. What has been said in the last paragraph is not intended to imply that we should let the boys have their fun and they will see the error

of their ways. There are no principles in art so rigid as to force us into the same strait-jacket. One hopes for depth and sincerity of response, for thoughtfulness in analysis, for confidence in judgement; and if one's pupils begin to show these during their time at school, then there is good hope that they will continue to be creative in their responses to art in their after-school lives.

The fifth point to be made is the necessity to be articulate. Without language much of the pupil's experience cannot be structured or communicated. The research work done in the U.S. during the years since the war has demonstrated beyond doubt that examination of the creative process in the arts yields an immense amount of valuable information. Much of this, incidentally, is available in this country, and could add greatly to establish a structure of thought by means of which relationships can be established between art and other modes of thought. He cannot even begin to do this unless he can begin to verbalize; and of what use is his art experience to him unless he can set it in a context and relate it to the rest of his experience? He needs to be able to discuss the nature of art experience, the criteria of art, the purpose of art. This would appear to indicate something more than the private conversations which are the basic teaching of the art lesson. Good as they are, they suffer from the weakness of all such private talk : a great deal of communication takes place which is not couched in formal language. Thus, although this is a teaching situation, no real structure of thought is developed. One feels that a more formal discussion is needed at which the art teacher – or whoever is the seminar leader – can begin to establish a common language and thus secure greater precision.

It must be emphasized here that there is no intention to depreciate or ignore the language of art, or in any sense whatever to suggest its replacement with words. The whole point of experience in art for young people is that here is a world in which they ought properly to be free, since the idea of liberal education implies that all should have access to man's thought at their own level, no matter what its structure. Art communicates (externalizes) that which cannot be verbalized in ways which cannot be verbalized : but words can be used with

purpose about the communications of art.

Finally, our last point is that the preceding matter seems to indicate that the arts should not be taught in isolation. There is no room here to explore this thesis fully; and no doubt in the next decade the development of cross-subject study and team-teaching will ensure that it is fully investigated. What would seem clear is that so far such attempts as have been made to explore relationships have been superficial – for example, the common procedure in art lessons in which a piece of music is played and the children paint. Possibly the concept of a starting point which might trigger off activity in art or music or poetry or dance is worth exploring; possibly too it would be worth while for the pupil as spectator and listener to adumbrate common ground.

We have been discussing art in schools of general education; it is pretty clear that the education of teachers who will be concerned with the teaching of art must develop the same goals, and must lead its students to a more thorough understanding of art both as participants and as spectators. Is the case for the education of the artist a different one? Can one argue that his job is to make art, not to know about it?

The question over-simplifies a complex problem. Students have an expectation of a college of art: they see themselves (in a most natural way) as particular people preparing to do a particular job. That job is practising art. To those who have never worked in a studio it is difficult to explain the atmosphere, the compulsive pull of the work, the feeling that time not spent in grappling with one's problem of the moment is time wasted. It is not surprising that the Hornsey students claim (in Document II) 'Art historical as well as complementary studies should be available throughout the course both formally and informally, *but not compulsorily*' [my emphasis]. They obviously wish to be free to make use of these courses or not, as the need occurs; but for them their course in practical art is central and other courses ancillary. How far the demand rests upon a true assessment of the situation must now be considered. All hinges upon the nature of the central course: if it is narrowly conceived – an old-style art school course con-

cerned primarily with the things made, then the difficulty of relating other study-subjects and activities to it is very great; and much recent student unrest is evidence of this. If however the central course concerns itself not only with art but also with the student, then the situation is different. The course then builds itself around the student's developing understanding of his abilities and needs; both he and his tutor participate in assembling a sequence of experiences – not diverse, but unified; and relating to clearly understood goals. It would seem that some at least of the trouble in schools of art has arisen because the current examinations have not been adequately thought through in relation to the supposed purpose of the courses. Perhaps because of a concern for the status of the Dip.A.D., the Coldstream Committee failed to devise a viable structure in terms of today's demands of the professional artist. It is, however, essential to remember that if you have a qualification it must be comparable to qualifications in other fields or it is useless. It is fair to say, also, that there is a real difficulty in attempting to assess what are the demands of society on the schools of art today.

At this point we should ask ourselves the question, 'What is the role of art in society?' It is often suggested that the artist fulfills an almost mystical role, that he sees farther than most people, that he is more aware of the present and its trends than most people – that the artist is the seer of the western world. One may agree that the artist, like practitioners of other arts, seems to live in tomorrow while most of us live in yesterday; yet this cannot surely be the whole truth. For the implication of this is that the arts are for artists to make and others to look at or respond to; a notion impossible to accept. It is true that we can all be creative lookers and listeners and users, but this is not enough; the insights that come from behaving artistically are for all to share. We are all artists; art as activity cannot help but be part of our waking lives. The development of our technology leaves many of us unsatisfied users of poorly-designed things; but this may be a transition stage. We may well be able to be far more creative in our choices and assembling of homes, for instance, as more ways

are found of giving us alternatives.

Art in education has therefore a key role to fill; for if we are all to behave as artists in life, we must have had at school the kind of experience and learning which will enable us to do so. This alone points to the fine-art-making of much contemporary art education as being inadequate in itself; it is too far removed from experience in ordinary life; too much merely a school activity. Yet not merely the activity must change, though this is essential; for in the complexity of contemporary life much of its richness is only within reach of those with a degree of sophistication and understanding. More than activity is needed if the individual is truly to feel that he has access to the best of the culture in which he lives, if he is to 'live at the height of his time'.

ART THROUGHOUT CHILDREN'S SCHOOLDAYS

When we think of children in schools of general education practising art, at present two concepts are almost universally regarded as important : one is expression, the other is freedom. It is assumed that children making art are expressing themselves; it is further assumed that children must be given freedom to express themselves – as often as possible, in every art lesson. Only examinations are allowed to interfere with these assumptions. We must now look at them more closely.

Whenever children participate in an activity they express themselves. This is no guarantee of the quality of the activity; and with increased opportunities for children to participate actively in what is going on in other areas of the curriculum, the need to provide for self-expression in the artroom or art lesson as a release or balancer has greatly diminished. In a more limited and precise sense, expression is recognized as the word used to mean the process of externalizing feeling or idea in the arts; it is evidently a fundamental element in creativity in art; and in this limited sense it is frequently used in this book.

The idea of freedom to express oneself needs more serious attention, since it represents a translation into teaching-actuality of the idea of art as an anarchic activity. The argu-

114

ment really starts from the fact that young children draw and paint with purpose and decision in a state of freedom; that is, untaught by the teacher or by an adult. Such constraints as are placed on the child tend on the whole not to limit or direct what the child does – so long as it is a drawing or painting in terms of the teacher's understanding. So that even here the freedom given is relative. In this sense it would appear that generally speaking the freedom given to children of any age to make art is contingent upon their doing so.

Even so, the notion exists that freedom is a condition of art, and this is strengthened by reference to the adult artist, who so clearly demands greater freedom than the child can have in school. The idea has therefore strengthened that freedom is not merely a prerequisite, but is the necessary condition: give children freedom and we shall have art.

We have learned through hard experience that this is not so, but we have not yet faced up to the implications of this discovery. The first must be that we must abandon the belief that the art of young children can be taught or perpetuated. The qualities of young children's work – the charm, spontaneity, liveliness – depend on factors beyond the teacher's reach, and paradoxically spring from the fact that young children are not primarily concerned to make art, but to state problems and to reach towards their solution. We have been preoccupied – probably understandably – with superficial aspects of this work (and indeed, perhaps this was fortunate, since this interest in young children's work as art was what set us on to the teaching of art in schools), but we must now look at children's work with greater understanding, and we shall cease to suppose that we can teach older children to make child-art.

Before we look at this matter again in the light of Piaget's developmental theories, there is one more word to be said about freedom and older children. We have seen that freedom is in any case relative; the older child practising art must learn that such freedom as he has is given to him so that he may himself set limits upon it. This freedom may lie in the areas of starting-point, or of medium, or of form, and choices in these areas are interrelated; so that the course might aim at helping pupils to

grasp the relationships in order to be able to make use of the freedom.

Young children drawing or painting or modelling must follow a track trodden by all their peers; they cannot help themselves. Their procedures are common to all, their development through schemata shows in all countries; their work has common attributes from China to Peru. Their single problem is a simple one: the mental development of concepts of man and his environment. They are in the early stages of what Piaget calls the 'stage of concrete operations'; they are developing means of structuring present-reality. Certainly up to the age of round about eleven, children are dependent upon material placed before them, or material already experienced, in order to operate; they cannot go systematically beyond this. It is useless to try to teach children in the stage of concrete operations 'by the rules'; they may well be able to work by the rules in a concrete situation, without at all being able to place their activity in a formal framework.

The indications here for the teacher are clear. The differentiating out of art and other modes of structuring present reality takes place during this period, in the sense that children can classify what they see or have experienced; and this process of classification must take place. But the identifying of art as art is a matter for children's understanding, not for the teacher. It follows, therefore, that in the early years – before nine – there is little place for the art lesson as such. One envisages children experimenting with all sorts of ways of organizing or exploring their world. These experiments naturally have form: to draw represents one form of structure. The drawing, however, is the trace of the mental structure, and therefore is important to the child only while it is being made. Gradually experiments crystallize down, not in teaching or in the teacher's mind, but in the child's understanding, as appropriate ways of exploring particular problems. This makes clearer the inappropriateness of art lessons: drawing or painting are possible means of exploration, not starting-points; they spring from the child's needs. To proclaim, 'Now we are going to paint', is to invert the process; and while very young children are never at

116

a loss while they have a schema to repeat, one soon finds children in an art lesson beginning to ask, 'What shall I paint, Miss?'

One sees, however, that there might be purely practical sessions when children are introduced to new media and techniques; but it must be emphasized that such technical processes are simply further tools to use; not in any sense at all end in themselves.

Of course the teacher has a part to play in helping the child to explore his environment; I am concerned to make the point that the teacher functions as a teacher who understands art, but not yet as an art teacher.

From the stage of concrete operations the child passes into the final stage of formal operations, described by Piaget as freeing the child from the necessity of working from what is present or has been experienced. He can now hypothesize, can think logically, and can give formal shape to ideas that formerly needed to be concrete. This process indicates an obvious development in art education; for if hitherto the child has been in process of discovering from his own experience what art can be, now his procedures can be formalized, related to each other and to theoretical ideas about art, and can be set into a total and developing pattern of understanding of art.

As has been suggested earlier, this may mean that pupils in the secondary school, in their approach and in their work, become far more self-conscious than they have hitherto been. This must be recognized as an inevitable stage of children growing up. It may also indicate that a stage will come when the focus of pupils' activities should shift away from practical work.

This may also indicate an increased tautness in the art lesson. The traditionally leisurely pace of the artroom, where quite evidently many pupils have not been extended, must yield to one which engages pupils purposefully in the development of ideas. Of course there must be times when children proceed at their own speed; but one visualizes far greater variations – slow as the work of preparing the ground goes on – quickening with enthusiasm as the idea develops; one sees times when one

piece of work follows fast upon another, or when sequences of events build up to a presentation of work.

It would seem possible that the depth and quality of artistic problems with which pupils are engaged might be more sophisticated than at present. This in turn might mean that, on a present basis of evaluation, the quality of work might drop. This will not matter, even if it does happen; but of course what could happen might be simply that work is different. Pupils with the kind of background in art which we have envisaged might much more rapidly move to self-initiated sequences of problems, and might be far more adventurous in devising techniques – not merely in practical art – to solve them.

PRACTICAL WORK RECONSIDERED

We have seen how the teacher's approach to the teaching of practical work ought to differ according to the age of the children being taught; how roughly to the age of nine children might use art-materials and the practice of drawing or painting or modelling and so on largely for the solution of their own problems; beginning to classify the tools they use – one of which is art. Piaget considers that the stage of concrete operations lasts until the age of eleven; Lowenfeld's 'Gang Age and Stage of Reasoning' occupy the years from nine to thirteen (Lowenfeld and Brittain, 1964). It would seem that for most children there is, at some time between the ages of nine and thirteen, a transition period during which they develop the process of differentiating out art as a cognitive tool with distinctive properties, begin to analyse what they are doing, and can begin to see art as an abstract idea. Certainly from the age of thirteen onwards pupils may be increasingly self-conscious about their own work, but are able to develop a total concept of art through experience and theoretical study.

Clearly, understanding and sympathetic teaching during the transition period is essential; it has been especially unfortunate for art education that the primary to secondary break comes at eleven, since both primary and secondary teachers have treated

118

their own period as a unity; transition has become utter division.

The change can be thought of crudely as a shift of focus from content to form. The young child is concerned to explore his environment, using any and all tools that come to hand; the teacher is therefore primarily involved in the child's relationship with his world, and with the tools he uses (McFee, 1961, explores this involvement in the exposition of her perception-delineation theory). It is important, therefore, that young children should be encouraged not to form preconceived ideas of what is art – e.g. that the 'right' thing to do with paint is paint a picture 'representing' something.

A great deal of research and study is needed on procedures during the transition period. It is clear that children will begin to think in a more and more conscious way about the things they make as art; the teacher's part must begin by creating a situation in which ideas can be exchanged about art as art, about meanings and about values. The relationship of children's own work to adult art will be explored; they may discover in their empirical efforts bases for mature concepts which can be defended theoretically. But all this will proceed at the child's pace; it is absolutely essential that throughout this period children should understand the steps they are taking. In addition we must bear in mind that developmental stages are only a rough guide to what may happen in a group of children; individuals will depart widely from the tidy ages proposed.

Curiosity about the environment provides starting points for work in the arts throughout the period before nine; and the subject matter of the pupil's work should surely continue to be provided by himself through the transition period and beyond. One can see also that the teacher has a role here and later in encouraging developments in practical work which will enable new concepts to be discovered. Margaret Bingham ('Art Education: the Learning Process and the Search for Structure', *Studies in Art Education*, ix, No. 2) has proposed an interesting model of the discipline of art. She sees it as an interlocking of 'functional' concepts, embodying the affective realm of meaning, values, emotion, with 'structural' concepts consisting of

119

three realms of design concepts, natural phenomena and relational concepts. Design concepts are line, shape, colour, texture, mass; these are so to speak the tools of the artist. The natural phenomena are space, light, mass, movement and time; by interlocking these two realms the relational concepts can be found: contrast, pattern, rhythm, balance, direction, variety and unity. Miss Bingham's article goes on to develop this model; here we observe that some such model could be invaluable for the art teacher in planning for the transition period and beyond.

To build a course broadly based on the stages discussed here would undoubtedly make greater demands on the art teacher, since the course must be more complex, must make even greater allowances for individual differences, and must include to a much greater degree than hitherto the study of philosophy, art criticism and art history. Practical work must therefore be designed to relate to these studies, which approach the understanding of art from different angles and which must key in with the experience of art gained from practical work. It is clearly no longer adequate to base a practical syllabus for a secondary school on such criteria as coverage or complexity. Nor is the typical art lesson as now generally conceived an adequate vehicle for the kind of content here adumbrated. One would wish to see a more fluid situation, both in space and time; some work will be teacher-initiated, more will be initiated by the pupils themselves; some work might be in response to assignments involving other disciplines, other work might develop out of problems sketched out by children. The implications of such procedures in terms of practical provision are for flexible working-spaces, available for different kinds of research; source-material of many kinds; a viewing-room with film- and slide-projectors and so on.

No discussion of practical work could be complete which disregarded the attempts frequently made to systematize it: division into art and craft, division by techniques, by materials, by content, by intention. In the end such frameworks have broken down; their rigidity has had to give way before continuous though not always consciously-realized processes of

change. Practical art in schools (and indeed in colleges of art – at least in foundation courses) has for many years now been moving away from the idea of craft-based courses with their emphasis on working within an established craft-framework. As yet no generally accepted structure has emerged to replace it; if and when it does, it will have to reflect first the desire to move freely across the craft-field (Hornsey 'network' courses are examples of this), and second, the shift away from the concept of expression as the central element in practical art towards the concept of exploration, with its implications about problem-solving and its emphasis on the blend of conscious and intuitive thought. Clearly, too, such a framework must not be allowed to become a limiting factor on courses, nor must it shape our attitudes – towards new media or old, towards ideas of content; particularly not towards what we actually ask or encourage children to do. Art is not art simply because it fits snugly into a category in an organizational framework.

PHILOSOPHY CRITICISM AND ART HISTORY

There can be few secondary schools where there are not some talks or film-shows on art, where something is not done in the art department about 'appreciation'; where the art teacher does not accept some responsibility for making a bridge between practical work and looking at and enjoying things made by others. Nevertheless, it remains true to say that in most secondary schools the main emphasis is on practical work, and the belief behind this is that the insights gained through practical work are largely sufficient, that the pupil will be able to make use of them without any further mediation than an occasional talk.

It has already been suggested that this belief is inadequate. For the experience of art is art seen from within; a total view of art must include art seen from without. This indicates looking at experience from outside, seeing the relationship between the doer, the process, and the thing made; considering meanings and values in art and their relationship with meanings and values elsewhere; and seeing art in a social context.

In the past, art teachers have felt that they were compelled to make a choice: time, they felt, was short; better to concentrate on practical experience. Besides, children have enough book-learning: creative activity is art's special contribution to education.

Time available for art is still limited, and is often inefficiently arranged, but it is difficult to believe that a great deal of the practical work that goes on is not dispensable. One feels that there are periods when many children would welcome a rest from having to make art to order. But these are only buttresses for the central argument: that it is no longer educationally sound to limit school art in a way which truncates discipline.

In any case, what is proposed here is an enhancement of practical work, in the sense that other studies must relate to practical work, and must elucidate it. Already, for example, teachers are wont to refer to reproductions or postcards when discussing the pupil's work with him: this procedure could form the starting point for serious and deep consideration of a number of fundamental matters concerning the artist and his inspiration, his processes of selection, the content of his work, and so on. Another train of thought might lead into a study of materials and techniques; yet another into discussions about the artist in his time – his social situation, his success or failure – and from here to looking at the artist in contemporary society. Part of the difficulty many teachers have in accepting such material in the artroom is that they think of ancillary activities in the artroom as contributing directly to the pupil working as an artist; what is here advocated is that all artroom activities – including practical work – shall contribute to the pupil's understanding of art as a human phenomenon.

One sees that a course structured in this way makes new demands on the teacher. He too must move with some freedom through the realms of philosophy, criticism, history. He must have material ready for the occasion when its use will be most appropriate or must devise sequences to open up certain avenues. It may be that such a course would demand team-teaching, with members of the team trained in new ways – art-historians, for example, capable of discourse in the related

122

areas of philosophy and criticism.

Further, such a shift of emphasis opens up new possibilities for the over-all shape of a pupil's course, for while some pupils may wish to focus their course upon practical work, others may become more interested in other approaches to the study of art. One sees these courses with a different focus as starting from the pupil's participation in a more or less common course; in other words, the change of direction is in effect the pupil's choice, and springs from his interest. Provided that the requirements outlined in chapter three can be met, it looks as though by the fourth form most boys and girls who are still taking art might be following their own courses : meeting as larger or smaller groups for certain purposes, and probably continuing to share a common core of studies; but each with his or her own centre of interest. Such arrangements would make it possible for the adolescent who has – possibly temporarily – lost interest in creative work in art to continue to participate in the study of art in a way meaningful to him; and it is worth stressing that, particularly at the secondary stage and at all levels of interest and ability, the global study of art may well be more appropriate for many children than the present insistence that they shall be creative to order. But the corollary, which must not be forgotten, is that there must always be opportunity for practical work which is perhaps more likely to be truly creative.

Courses structured in this way evidently need different kinds of provision; we have discussed space requirements earlier in this chapter; but any course which deals with art from the observer's point of view has special needs in source-material. Access to original works of art is essential – works of all kinds – not simply fine art. Some education authorities have school museum services; many more have loan collections of original paintings, sculpture, etc.; some fortunate schools and colleges have their own collection. Most schools, however, are dependent upon their local art gallery and museum. The relationship between them is a developing one, but there are serious problems to be solved before use of galleries by schools works as freely as it should.

At present visits to galleries and museums are special occasions for schools, being comparatively rare and infrequent. Yet older children at least studying art will surely need frequent visits and perhaps special facilities. Herein lies a real difficulty : galleries are turning their attention to their educational responsibilities more seriously, but their space is strictly limited, demands may be great, and behind all stands the figure of conservation, to ensure that galleries do not forget what is conceived to be their proper task. Naturally enough, therefore, galleries are making their own preparations to do what they can for schools. There is thus a danger that galleries will make certain offerings which schools will have to take or leave; when in fact exactly the opposite is educationally desirable : school use of the gallery is part of an educational whole which ideally should not be distorted by the action of one of its parts. It would, therefore, be highly undesirable for galleries and museums to become teaching institutions outside the school. Naturally the fullest co-operation is necessary, but its purpose must be to ensure that children are able to get from the gallery what their course requires.

The clear implication of what has been said above is that when children visit a gallery or museum they know what they are looking for. A first visit is one thing; but subsequent visits would seem much more likely to be useful if they are for a limited and understood purpose. This purpose may only be 'appreciation' in the broadest sense – and may hardly be that. We must be sure that pupils have a real choice, even if their interest seems to stray right to the boundaries of art education and beyond. We have been too parochial in the past. And of course what has been said here about the use of galleries and museums must not be taken to intend a focus upon the past. Children must see the art of their own time in the context of the past, but in no sense must the study of the past hold them back. They will grow up tomorrow.

ART EDUCATION AND SOCIETY

In 1857 Ruskin said in a lecture : 'Wherever you go, whatever

you do, act more for preservation and less for production.'
Strange words from Ruskin, who so strongly spoke for the
Pre-Raphaelites and for Turner. Yet perhaps since his time our
society has suffered from a split vision in this matter. To con-
serve, or to reconstruct, or to replace – the argument is a
recurrent one. We have a National Trust, and we have ruined
Bloomsbury ; we preserve with one hand, destroy with the
other; and we have little confidence in what we make that is
new.

In a period of immense change some nostalgia for the past is
inevitable. So there are all sorts of societies – Archaeological
Societies, Canal Societies, Vintage Car Owners and so on –
composed of people with a feeling for the past and an urge to
preserve contact with it. Some of these people are active in
campaigning, others discover or record or collect; yet others
simply enjoy looking or touching or listening. For many people
this interest in the past has made a new dimension, has given a
purpose to their leisure time.

There are others for whom the past has little appeal. They
are concerned with their own lives, their dress, their homes,
the contemporary arts. One most hopeful sign for the arts
today is the enthusiasm shown by young people for what is
good in contemporary art and design, and their independence
in developing styles and ideas of their own where this can be
done. Young painters and designers are pre-eminent in certain
fields.

At the same time the general level of design is low. Collectors
of antiques are on safe ground, and perhaps it is not surprising
that reproduction antiques are popular. But the person who is
looking for objects designed for today will have the greatest
difficulty in picking his way through the fake, the ill-designed,
the ephemeral, the fashionable – will indeed be lucky if he
finds what he is looking for. Yet in the fine arts the standard of
exhibitions has never been so high : the Arts Council travelling
exhibitions have brought new life to many a provincial gallery,
while special or retrospective exhibitions, admirably docu-
mented, have acted as teaching exhibitions, opening new
avenues of understanding for many thousands of people.

There is here a complete lack of cultural unity. On the one hand a great deal of our physical surroundings owes its form and character less to the needs of society than to the demands of technology and commerce, so that it is possible to speak of our cities as aesthetic slums. On the other hand, there seems to be evidence of lively and active interest in the arts by groups of people, many of whom are young. It would seem that this interest is not always very informed nor very discriminating; and it does not generate in any sense that degree of force which is needed to make changes in our man-made environment; though perhaps its influence in people's personal environments is much greater.

It would be a profound mistake to suppose that art education alone should carry the responsibility for this unhappy state of affairs. Social forces are at work, the balance among which is more than the business of one group alone; and yet it is true that the art educator does have some contact in school with every child. The question is bound to be asked: is art education doing its job properly? Should not our future administrators, managers, headmasters, leave school with a clearer and more powerful understanding of the arts in the life of the individual and of society?

There is a paradox in the relation of art education to society. On the one hand society spends a good deal of money on art education. The Royal College of Art has achieved university status; there are still a great many schools of art (40 offering Dip.A.D.) and art departments in institutes of further education; there are many universities teaching art or art history; every college of education has an art department; art is taught in every secondary school, while most comprehensive schools have departments with three or more teachers; finally, art is taught in every junior and every infant school in the kingdom. To teach art requires space, equipment and expendable materials: these are not cheap, although no one teaching art ever has enough.

On the other hand, in other ways society does not appear to value art education very highly. The colleges of art have suffered two changes of examination system in twenty years;

in neither case was there any adequate inquiry into the purposes of art education in the colleges; and the procedures for establishing Dip.A.D., although well intentioned, have proved not to be in the best interests of schools or students. Colleges of art have seldom been much valued by their communities; local authorities have kept a tight hand on administration; only recently have the colleges secured any degree of autonomy. The Prentice Committee, set up by the Department of Education and Science, which recommended that polytechnics should be set up, had no representative of the schools of art on it.

In schools of general education art would appear to have established a place – yet in secondary schools that place is relatively unimportant. Art is not a useful subject for university entrance; it is claimed not to be an intellectual subject; anyone can do it. It is useful in the sense that it provides a pretty secure G.C.E. pass for less intelligent pupils, and makes a change in the timetable from other subjects which involve more effort. So many headmasters exhibit attitudes of good-humoured tolerance, reflected in the small allowance to many art departments; the fact that art is now the only practical subject in which it is still supposed that one teacher can take a whole class; the inadequate provision of space and equipment. There are of course notable exceptions to this generalization: it remains true to say than in many – perhaps most – secondary schools art has still to win full acceptance.

In the primary schools the situation is different but equally unhappy. Great emphasis is placed on art in the curriculum, yet art is taught by class-teachers inadequately trained, who will often admit their incapacity and uncertainty in the subject.

Moreover, for their contacts with the public and with parents the schools of general education rely heavily on the arts. The school play, the school exhibition, the school orchestra, dance and movement – through all these the schools seek to present an image of themselves. Like examinations these manifestations cut across all educational activities, becoming meaningless when aping adult standards or appearing isolated from educational significance.

What of children and art? We have all seen small children

practising the arts in an artless and undifferentiated way – moving from one form of expression to another freely as the creative flow takes them. The arts are not strange or esoteric to the young child; he moves in them as naturally as a fish in water. Adults enjoy watching him, respond to the innocent vitality of these untutored activities.

But children grow up; and the forms taken by their growing efforts to structure their experience are not always acceptable in terms of taste or social usage or morality. In the arts, as elsewhere, the child comes up against authority. He learns that some subjects are taboo, that there are prescribed forms, that there are techniques to be learned. He learns to adapt – perhaps too readily – often because he so enjoys doing. Even in the strait-jacket of G.C.E. he finds his own satisfaction in his work. But for most children by this stage things have gone irreparably wrong. Art has become ART – unattainable, remote; what he does himself is no longer functional in terms of his needs and interests; is merely a vestigial thing, a reminder of times past. The gap is too wide; and many children are left to assume that they will never be artists, that they are left on the outside.

It is the purpose of this book to suggest that this need not be so, and that the study of the arts throughout children's schooldays need exclude no one. Where weakness in personal attainment appears to close doors other means must be adopted to keep them open. In the normal processes of change and development we must give a new orientation to art education.

Bibliography

This list, which includes books and periodicals referred to in the text, is in no sense exhaustive. It is arranged in five groups for ease of reference, and books useful as first reading are starred thus*.

1 These books are concerned with the historical development of ideas in art education and their implementation, or are themselves part of that development:

ABLETT T. R., (1889), *How to Teach Drawing in Elementary Schools*, London, Blackie.

BAYER HERBERT and GROPIUS WALTER, (1952), *Bauhaus 1919-1928*, N.Y., Mus. Mod. Art.

BELL QUENTIN, (1963), *The Schools of Design*, London, Routledge & Kegan Paul.

CARLINE RICHARD, (1968), *Draw They Must*, London, Arnold.

COLDSTREAM REPORT, (1960), *The First Report of the National Advisory Committee on Art Education*, H.M.S.O.

COOKE EBENEZER, (1885/6), 'Our Art-Teaching and Child-Nature', *Journal of Education*.

ECCOTT ROSALIND and ARTHUR, (1935), *Teaching Creative Art in Schools*, Evans Bros.

HAUSER ARNOLD, (1951), *Social History of Art*, London, Routledge & Kegan Paul.

MINISTRY OF EDUCATION, (1946), *Art Education Pamphlet No. 6*, H.M.S.O.

PEVSNER NICHOLAS, (1940), *Academies of Art*, Camb. Univ. Press.

RUSKIN JOHN, (1857, reprinted 1907), *Elements of Drawing*, London, Dent.

SPENCER, HERBERT, (1861), *Education Intellectual, Moral and Physical*, London, Williams & Norgate

SUTTON GORDON, (1967), *Artisan or Artist?* London, Pergamon Press.

*TOMLINSON R. R., (1943), *Children as Artists*, London, Penguin.

2 These books deal with the philosophical and educational background:

*BRUNER JEROME S., (1960), *The Process of Education*, New York, Vintage Books.

DEWEY JOHN, (1916), *Democracy and Education*, London, Macmillan.

HIRST PAUL H., *Philosophical Foundations of the Curriculum* to be published in this series.

LANGER SUSANNE, (1951), *Philosophy in a New Key*, London, Oxford Univ. Press.

PETERS RICHARD S., (1964), *Education as Initiation*, London, Evans Bros.

READ SIR HERBERT, (1955), *Icon and Idea*, London, Faber.

REID LOUIS ARNAUD, (1961), *Ways of Knowledge and Experience*, London, Allen & Unwin.

3 These books are concerned with psychological aspects of artistic activity:

ARNHEIM RUDOLPH, (1954), *Art and Visual Perception*, Berkeley Univ. of California Press.

EHRENZWEIG ANTON, (1953), *Psychoanalysis of Artistic Vision and Hearing*, London, Routledge & Kegan Paul.

*ENG, HELGA, (1954 & 1957), *The Psychology of Child and Youth Drawings*, 2 vols., London, Routledge & Kegan Paul.

FLAVELL JOHN H., (1963), *The Developmental Psychology of Jean Piaget*, New York, Van Nostrand.

*GREGORY R. L., (1966), *Eye and Brain*, London, World Univ. Lib.

KELLOGG RHODA, (1959), *What Children Scribble & Why*, Palo Alto, National Press Books, (out of print, but her new book *Analysing Children's Art* is due to be published this year, 1969).

MORRIS DESMOND, (1962), *The Biology of Art*, London, Methuen.

MORRIS DESMOND, (1967), *The Naked Ape* (chapter on Discovery), London, Methuen.

ROBERTSON SEONAID, (1963), *Rosegarden and Labyrinth*, London, Routledge & Kegan Paul.

VERNON M. D., (1962), *The Psychology of Perception*, London, Penguin.

4 These books are concerned especially with creativity and with the development of creative abilities:

GETZELS J. W. and JACKSON P. W., (1962), *Creativity and Intelligence*, New York, Wiley.

*GHISELIN BREWSTER, (1952), *The Creative Process: a Symposium*, Univ. of California Press.

GOWAN J., DEMOS G., and TORRANCE E. PAUL, (1967), *Creativity; its Educational Implications*, London, New York, Wiley.

*HUDSON LIAM, (1966), *Contrary Imaginations*, London, Methuen.

KOESTLER ARTHUR, (1964), *The Act of Creation*, London, Hutchinson.

LOWENFELD VIKTOR, (1939), *The Nature of Creative Activity*, London, Routledge & Kegan Paul.

MCKELLAR PETER, (1957), *Imagination and Thinking*, London, Cohen & West.

PARNES SIDNEY and HARDING HAROLD, (1962), *A Source Book for Creative Thinking*, New York, Scribner.

TORRANCE E. PAUL, (1962), *Guiding Creative Talent*, N.J., Prentice-Hall.

5 These books are valuable for the direct study of art education; almost all deal with theoretical aspects – none are concerned only with method:

DEWEY JOHN, (1934), *Art as Experience*, New York, Putnam.

EISNER ELLIOTT and ECKER DAVID, (1966), *Readings in Art Education*, Mass., Blaisdell.

GROZINGER WOLFGANG, (1955), *Scribbling, Drawing, Painting*, London, Faber.

*LOWENFELD VIKTOR and BRITTAIN LAMBERT, (1964), *Creative and Mental Growth*, New York, Collier/Macmillan.

MANZELLA DAVID, (1963), *Educationists and the Evisceration of the Visual Arts*, Pennsylvania, International Textbook Co.

MCFEE JUNE KING, (1961), *Preparation for Art*, Calif., Wadsworth.

NEWICK JOHN, (1964), *Clay and Terracotta in Education*, Leics., Dryad.

READ SIR HERBERT, (1955), *The Grassroots of Art*, London, Faber.

READ SIR HERBERT, (1943), *Education through Art*, London, Faber.

RICHARDSON MARION, (1948), *Art and the Child*, London Univ. of London Press.

ROBERTSON SEONAID, (1963), *Creative Crafts in Education*, London, Routledge & Kegan Paul.

SAUSMAREZ MAURICE de, (1964), *Basic Design: the Dynamics of Visual Form*, London, Studio Vista.

SCHAEFER-SIMMERN HENRY, (1950), *The Unfolding of Artistic Activity*, Berkeley Univ. of California Press.

*SHAHN BEN, (1957), *The Shape of Content*, Cambridge, Mass. Harvard Univ. Press.

SMITH RALPH A. (ed.) (1966), *Aesthetics and Criticism in Art Education*, Chicago, Rand McNally & Co.

VIOLA WILHELM, (1942), *Child Art*, Univ. of London Press.

6 Periodicals

Art Education. Published nine times yearly. National Art Education Association, 1201 Sixteenth St., Northwest, Washington, D.C.

Athene. Published four times yearly. Society for Education through Art, 29 Great James St., London, W.C.1.

Craft Horizons. Published six times yearly, American Craftsman's Council, 44, W. Fifty-Third St., New York 19.

Design Education. Occasional, Postgraduate Studies, Hornsey College of Art, Crouch End Hill, London, N.8.

Studies in Art Education: a Journal of Issues and Research in Art Education published three times yearly, as *Art Education* above.

Index

Bulley, Margaret 57
Butler, Reg 59

Centres of Art Teacher Education 96, 98-101
advanced courses and research 101
Certificate of Secondary Education 80-81, 83
Cezanne, Paul 43
child-centred education 51-55
children and art 65-72, 127-128
children's art 4-6
choice 7, 27, 28
Cizek Franz 5, 16, 44, 53-54, 62-63, 65
cognitive ability 52
coherence of organization 40-41
Coldstream Committee 92 et seq., 113
Colleges (Schools) of Art 63-64, 75, 81, 82, 90-98, 101, 112, 126-127
Colleges of Education 75, 85-90, 126
see Training Colleges
Bachelor of Education degree 89-90, 102, 103
main and professional courses 87-89
communication 111-112
compartmentation 75
complementary studies 92-94, 112
comprehensive schools 104-106
confidence 26, 77, 110
Congo 41
Consultative Committee on Practical Work in Secondary Schools 1913 60
contemporary scene, the ch. 1
Cooke, Ebenezer 5, 50, 53
craft, definition 3
handcrafts 50, 60, 108
handicraft 58, 60
craftsmanship 56, 59-60
see skill
creativity 7, 31-46
chronological model of 32-35
creative abilities 35 et seq.
creative activity 21, 28, 76, 77, 88
creative experience 108
creative process 32, 108
criticism 43, 46, 90, 121-124

cross-subject teaching 104-105, 112
see interdisciplinary teaching
curiosity 36
curriculum 50

Dalton Plan 51
Darwin, Sir Robin 57
deductive thinking 25
Department of Education and Science 127
design, definition 3, 48, 55-61, 125
Design Centre 110
Design and Industries Association 57
designer 122
De Stijl and Mondrian 63
development 41-32, 44, 66-68, 76-80, 108, 119
students in Colleges of Education 86-87
Dewey, John 9, 33, 45, 51-53
Diploma in Art and Design 90 et seq., 99, 102, 103, 113, 127
see National Diploma in Design
discovery 18, 81
discrimination 110
see appreciation, judgment, taste
Dudley High School 54, 63

Eccott, Arthur 99
Eccott, Rosemary and Arthur 54
Ecker, David 42
education in art 4
education through art 4, 55
Eisner, Elliott W. 55
elaboration 40
embodiment 23-24
end-product 11, 32
Eng, Helga 65-66
environment 21, 25, 28, 42, 57, 65, 68, 77, 107, 109, 119
evaluation 41-42, 45
examinations 11, 83, 113
see G.C.E., C.S.E., N.D.D., Dip.A.D.
exhibitions 75, 125
school 127
teaching 65
travelling 65
experience 18, 20, 42, 46, 52, 69-71, 76, 77, 118, 121
experiment 18, 116